Volume Three

HOW TO PAINT TROUT

FISH·CARVING Basics

Volume Three

HOW TO PAINT TROUT

Curtis J. Badger

STACKPOLE
BOOKS

Published by
STACKPOLE BOOKS
5067 Ritter Road
Mechanicsburg, PA 17055

Printed in Hong Kong

10 9 8 7 6 5 4 3 2 1

First edition

Cover design by Caroline Miller

Interior design by Marcia Lee Dobbs

Library of Congress Cataloging-in-Publication Data

Badger, Curtis J.
 Fish carving basics.

 Contents: v. 1. How to Carve.—v. 2. How to paint.
 1. Wood-carving—Technique. 2. Fishes in art.
 3. Painting—Technique. I. Title.
TT199.7.B335 1994 731'.832 93-30588
ISBN 0-8117-2524-3 (v. 1)
ISBN 0-8117-2440-9 (v. 2)
ISBN 0-8117-2458-1 (v. 3)

Contents

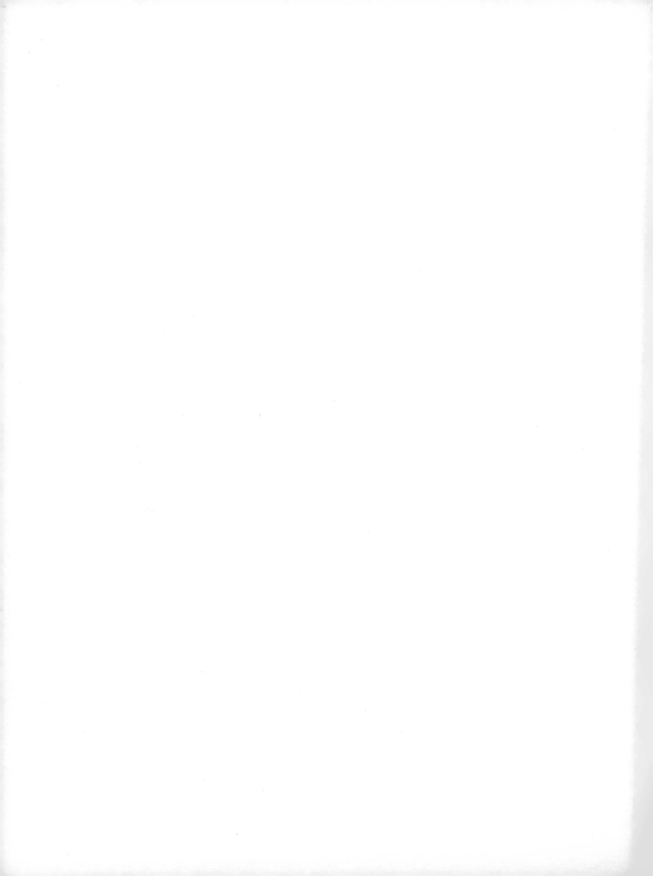

Foreword

The trout may be America's favorite fish. For one thing, all species of trout are beautiful to look at. The form is sleek, the coloration covers the entire visual spectrum, and trout somehow seem inherently more graceful than other fish. Plus, trout live in places that please the human eye. Think of trout fishing and you picture cool mountain streams, gentle riffles, and deep eddies, golden fall leaves being swept along on the current.

Unlike other fish, the trout takes on a nearly religious quality in human life. It appears in our art and in our literature. In Ernest Hemingway's "Big Two-Hearted River," trout fishing is a mystical rite of healing. In Norman Maclean's *A River Runs through It*, trout fishing is part of a family's bonding process.

Small wonder, then, that when it comes to the world of realistic fish carving, trout are high on the list of most artists. This volume includes the work of four of the top trout carvers in North America: Rick Roth of Massachusetts, Kevin Currier of New Hampshire, Clark Schreibeis of Montana, and Mike Windauer, another Montanan who was living in Oregon while attending dental school when this book was being prepared.

All four artists have excelled in national carving competitions, and their work is included in some of the leading collections in the country. Indeed, all four have won awards in the Global Carving Challenge—Aquatic Life, which was begun in 1992 by Wood Carvers Supply, Inc., of Englewood, Florida.

"The purpose of the competition was to encourage carvers to stretch the limits of their imaginations and

abilities and inject powerful emotions into their work," says corporation president Timothy Effrem. "By emphasizing emotion as a judging criterion, the entire composition of each piece was affected from the earliest planning stage to completion. Emotion produces maximum impact and allows the viewer to share the artist's feelings about the subject. When properly executed, emotion elevates carving to fine art, and I think that this ability is shared by all four carvers represented in this book.

"Clark Schreibeis was a first-place winner and was named Global Champion in the first competition held in Norfolk, Virginia, in 1992. Mike Windauer was a first-place winner in 1993, and Rick Roth won a first and Kevin Currier an honorable mention in 1994. Readers have an opportunity through this book to learn from four of the best realistic freshwater carvers in the country. Each has graciously and generously shared his talents, techniques, and experience."

Timothy Effrem and his wife, Deborah, have supported the art of wood carving in many ways, including sponsorship of the Global Carving Challenge, which Deborah chairs. In addition, they have both worked tirelessly to promote aquatic life wood carving as an art form. They helped with this series by introducing me to many talented carvers, and they supplied the excellent photographs of the artists' work seen in the Gallery section of this book. For more information on the Global Challenge or for a free catalog of carving supplies, contact them at Wood Carvers Supply, Inc., P.O. Box 7500, Englewood, FL 34295-7500, or phone 941-698-0123 or 800-284-6229.

Before the carvers begin their demonstrations, I would like to thank them for allowing me to look on with the camera as they worked. It always is a pleasure to watch artists go about the creative process in their own individual ways. I hope you will learn from these four talented carvers, and that you will use those skills to stretch your own imagination and ability. Who knows? A Global Challenge trophy could be in your future.

1
Rick Roth

Painting a Brown Trout with

Settle back in Rick Roth's Massachusetts carving studio and you'll quickly forget you are but a few minutes from downtown Boston. His home is at the end of a long dirt lane near the town of Littleton. Ninety-six acres of forest surround the property, muffling out the drone of traffic on I-495. The carving studio is a short walk from the house, just past a garden where tomatoes and squash grow in the summer.

Adjacent to the building is the residence of Homer the potbellied pig. Homer, who apparently has missed few meals, is a good, quiet neighbor, except for when he and Lady the dog have their differences of opinion. On such occasions, Rick is called upon to referee.

The Roth home is part of the ninety-six-acre Sarah Doublet Forest preserve, a tract once owned by Native Americans. The preserve is currently owned by a private land trust, and the Roths are caretakers, enjoying the bucolic country life in exchange for keeping an eye out for marauding vandals and other ne'er-do-wells.

Since Rick became a professional fish carver four years ago, this has been his office, studio, factory, and retreat. There is a band saw; a bench covered with various fish in assorted degrees of completion; shelves filled with books, photos, and other reference material; and the painting station, where I visited him during this demonstration.

Rick Roth is a master of the airbrush, an instrument capable of replicating the countless subtle hues of a fish but which can be maddeningly frustrating when it spits and spatters or refuses to emit color.

Homer the pig has witnessed various wooden fish fly out the shop window on such occasions, Rick admits.

Such occasions are rare these days. After more than four years of almost daily work with the airbrush, Rick can make it sing. He makes it look easy.

In this session, he paints one of his favorite fish, the brown trout. Rick is an angler who appreciates fish on several different levels: as a sportsman, an artist, a naturalist. Indeed, he learned a great deal about fish while working in the aquarium business and he once owned his own shop. These days, however, the only fish in the Roth household are of the tupelo persuasion. "I don't have to feed them," Rick says.

Rick became interested in fish carving while in the aquarium business. "I had worked in the industry for a good while and was looking for something else," he says. "One day my Dad and I went to a local gallery and saw some bird carvings. I was really impressed with them, and for my next birthday Dad got me a book on fish carving, along with some carving supplies. I did one of the projects in the book, and to my surprise the gallery bought it. I figured it would be a way to make some extra money."

As Rick's skills improved, so did his market and asking price. Within a year, he was able to leave the aquarium business and become a full-time carver. He sells through galleries and to private collectors, many of whom have become familiar with his work through competitions such as the Global Carving Challenge. Rick won a first for realistic freshwater fish in the Global in 1993 and has numerous other awards from competitions around the country, including the Wisconsin Master Carving Competition, the New England Wildlife Art Expo, and the Massachusetts Audubon Society.

In this demonstration he paints the brown trout using Polytranspar brand water-based taxidermy colors and his airbrush. Polytranspar paints are distributed by Wasco, 1306 West Spring St., P.O. Box 567, Monroe, GA 30655. The airbrush is a good tool for painting fish, he believes, because it can apply thin transparent washes of color that change subtly with the angle of light striking the fish, just as in nature. In nearly all cases, the paints are applied straight from the bottle and are not mixed. Rick uses water to dilute

paints if necessary, and a diluting medium the same consistency as the paint is used to tone down colors.

When painting, Rick uses color photos of fish and his notes from past projects for reference. "You can catch a brown trout in one place and it will look totally different from one caught in another," he says. "I've caught brown trout in the Great Lakes and they look nothing at all like the trout I catch in streams that empty into the Great Lakes. So you really have a lot of leeway, and you can just concentrate on painting a pretty fish."

It's important, Rick believes, to pick a paint system and become familiar with it because certain paints, such as metallics and pearl essences, need to be applied in a specific order for optimal results.

Scales have already been stenciled on the fish (see chapter 2), and it has been primed with gesso.

For information on Rick Roth's carving and painting seminars, contact him at 132 Nashoba Road, Littleton, MA 01460.

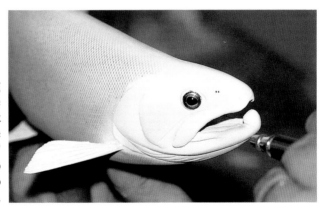

Rick begins the painting process with the inside of the fish's open mouth. "If I get overspray on the face of the fish, I can cover it later," he says. He begins with Wasco flesh, spraying it into the mouth.

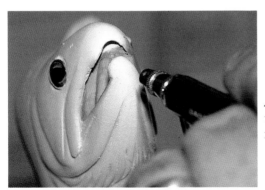

After the flesh color is applied, black umber is sprayed into the back of the mouth to create the illusion of depth.

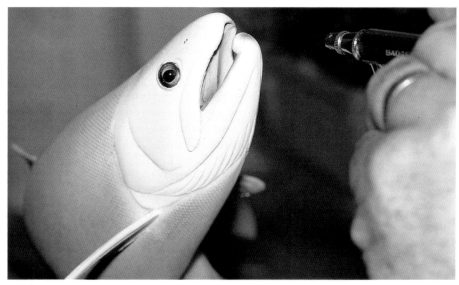

Male fish develop a *kype*, a slight protrusion on the lower mandible, and a recessed area on the upper mandible for the kype to fit into. Rick darkens the recessed area with an application of black umber.

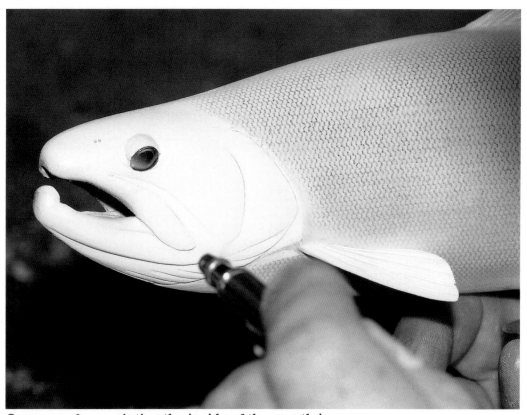

Overspray from painting the inside of the mouth is covered with a light application of Wasco super-hide white.

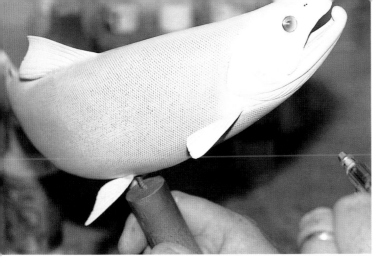

Rick now paints the trout with silver pearl essence to give it a subtle shimmering effect. The silver pearl will show through later applications of color. He paints the head and mandibles but avoids painting the fins because the metallic paint will interfere with the quality of translucency he wants there.

Metallic blue is applied to the sides and head of the fish, and this, too, will show through subsequent applications of color, creating a shimmering effect. Rick usually begins painting on the back side of the fish. Any errors or adjustments can be made there, before the front is painted.

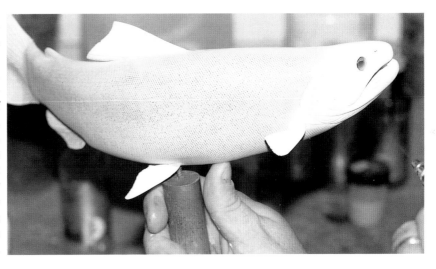

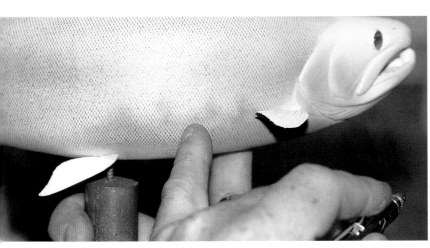

The lower sides of the trout are a yellow-gold color, which Rick replicates by first applying yellow ocher in a random pattern, followed by a mist of sparkling gold. He is careful to apply both colors in thin mists to avoid blocking up the scale pattern.

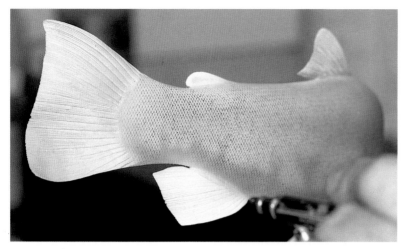

Yellow ocher is sprayed in random patterns along the belly of the fish and on the gill covers and caudal, or tail, fin.

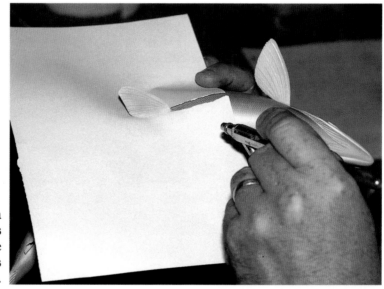

A piece of paper with a slit cut in it is used to mask the body of the fish as Rick paints each fin.

All of the fins are painted, and with the first application of color completed, the trout looks like this.

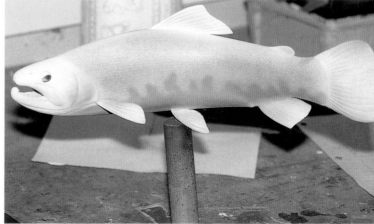

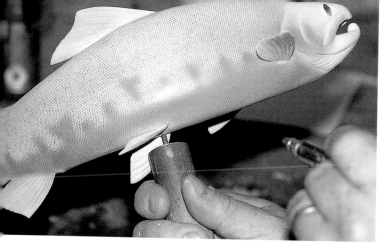

Sparking gold is now applied to the gill covers, face, and belly. Again, it's important to avoid getting metallic paint on the fins because it makes them look opaque rather than translucent.

Brown trout in streams often have a reddish tint overlaying the yellow-gold area, and Rick creates this by applying a very fine mist coat of bright orange over the lower portions of the yellow area. "This should be very subtle," he says. "You don't even want to see the paint go on. You should just see very slight change in color on the fish." The bright orange is followed by a very light mist of flesh.

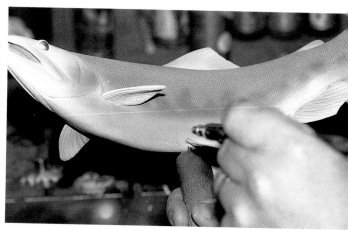

Wasco's medium bass green, a taxidermy color, is used on the sides and back of the trout. In conventional colors, Hookers green would be a close match. Rick sprays the dorsal fin and then goes down the back.

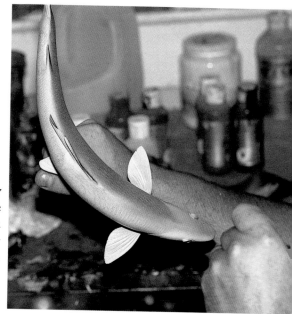

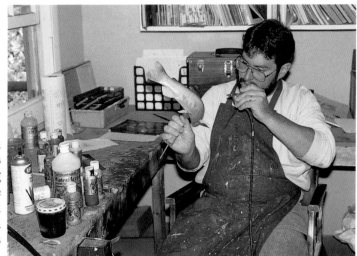

Rick darkens the back of the trout and allows the color to fall off along the sides where the lateral line will be. Rick will add the lateral line when he scale-tips the trout.

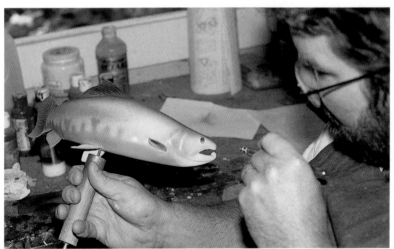

A light mist of violet is sprayed over the metallic blue applied earlier to the sides and head. Violet is a dark, strong color, so it is diluted with clear coat to create a more subtle value.

Rick is ready to start the spot pattern on the trout. Before he begins painting the fish, he practices on a piece of paper, adjusting the set screw on his airbrush to create a halo with a soft edge. Later, when he paints the dark center spots, he will adjust the brush to give a more sharply defined circle.

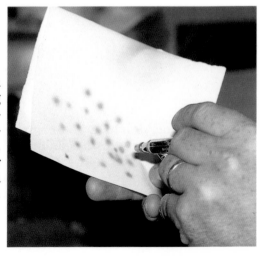

On the lower areas of the fish the spots consist of a sienna halo with a dark center spot. Along the upper back, the spots will be dark. A few red spots will also be added. Here Rick begins by spraying sienna spots on the lower sides of the trout. If the paint spatters, he reduces its consistency by adding a small amount of water. A few drops of retarder are also added to avoid having paint dry on the needle of the airbrush, a problem that can cause spattering.

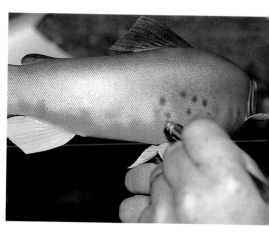

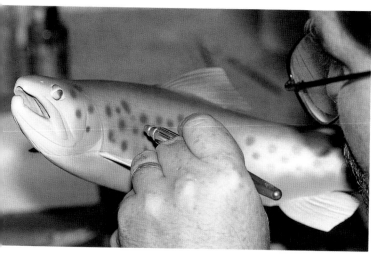

Spots go on the gill covers as well as the body of the fish. Note that the spots are not perfect circles but are irregularly shaped.

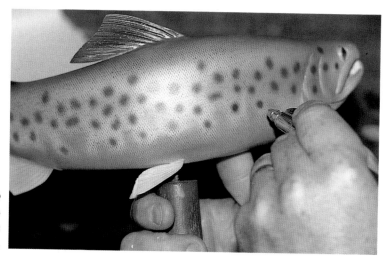

Cadmium red is used to create bright red spots and to lighten some of the sienna spots.

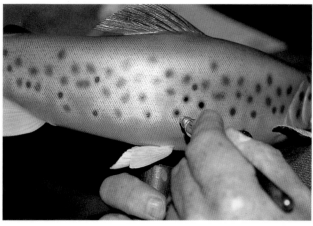

Black umber is used for the dark spots, and Rick adds a small amount of straight black to darken and cool the color. The airbrush is adjusted to paint a tighter, more defined spot, and these are applied over the sienna spots, creating a halo effect.

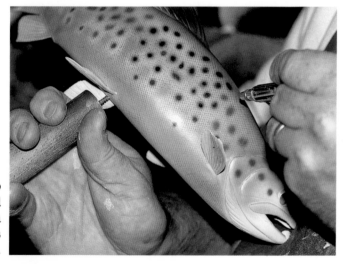

Black spots are applied to the back of the trout, and again Rick paints them in a random pattern and avoids creating perfect circles.

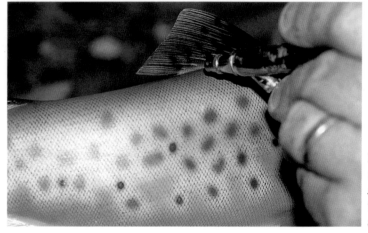

Here Rick sprays dark spots on the dorsal fin. All of the upper fins—the dorsal, adipose, and caudal—get spots.

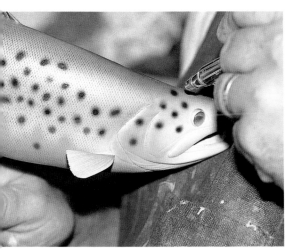

Chocolate brown is used to mist the back of the trout, darkening it and giving it a warm value.

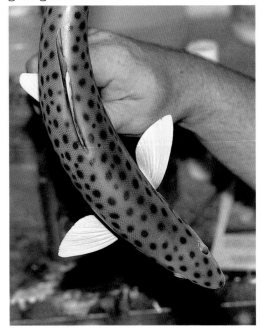

Spots along the body of the fish can be touched up slightly during the scale-tipping process, but because there are no scales on the face of the fish, care must be taken to paint the spots with precision. "There is no margin for error here," Rick says.

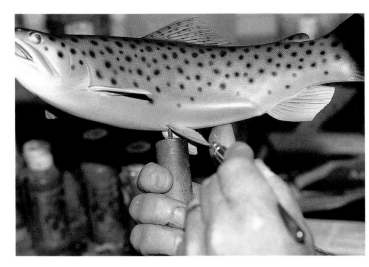

Brown is applied to the front of the lower fins, making them closer to the color value of the body of the fish. "I don't want them too yellow," says Rick. "A misting will push the color closer to that of the body of the fish."

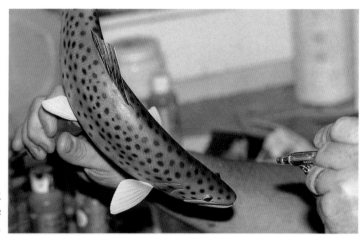

Rick goes back to black to further darken the top of the trout.

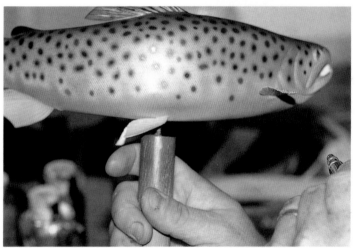

On the male trout, a subtle smoky line runs from the pectoral fins to the anal fins, and Rick paints this with black.

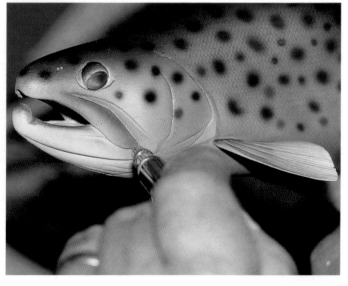

Detail work in the face area is done with black. The area behind the maxillary bone is darkened here. Rick switches to a fine needle and head on his airbrush to do some of the detail work.

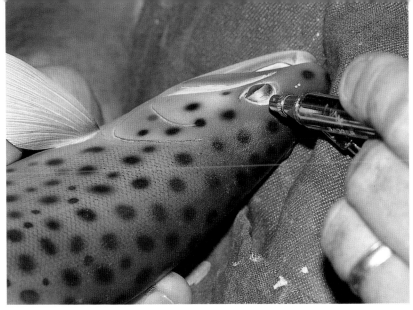

This eye is looking down, and the area above it will show some white. Rick applies the white with a small paintbrush and then blends black into it with the airbrush, creating a soft edge.

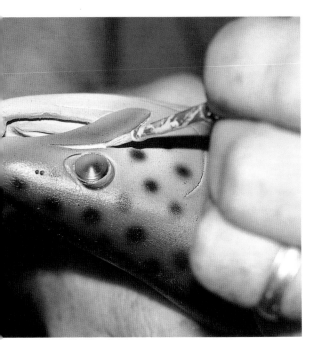

The membrane behind the maxillary bone is painted white with the small brush.

Super-hide white is used to mist the edges of the fins, adding to the illusion of translucency.

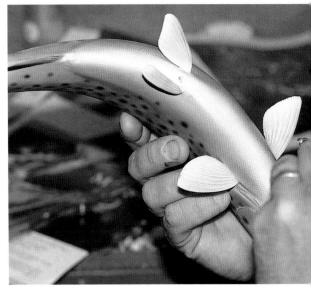

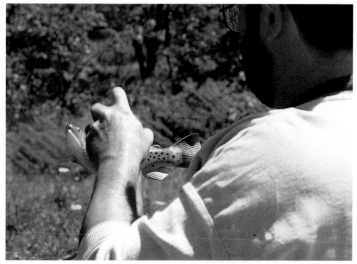

Before scale-tipping, Rick sprays the fish with Wasco Super Gloss, which provides a wet look and adds saturation to the colors. The paint should be dry before spraying, or cracking could occur. He applies a quick flash coat of gloss, allows that to dry, then gives the trout a second application. Spraying is done outdoors to avoid fumes.

Before scale-tipping, Rick cleans paint from the eye of the trout with a knife blade. Note the various color values of the spots on the fish. They include straight black on the back, sienna and black on the belly, and straight red applied at random.

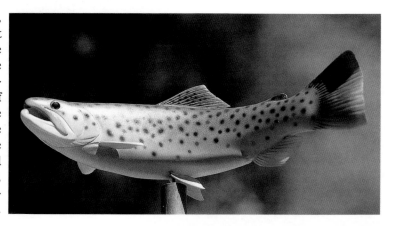

Scale-tipping is done with silver pearl essence, applied with a #3 brush whose tip has been cut off. Rick dips the brush into the paint and dabs a small amount of pearl essence onto the scales. He tips all the scales on the upper part of the fish and about half in the lower, yellow area.

The dab of pearl goes in the center of each scale, leaving an area of paint as an outline. Pearl essence is available in art and taxidermy supply stores. It consists of pigment to which has been added either crushed pearl or mica to create a slightly reflective surface.

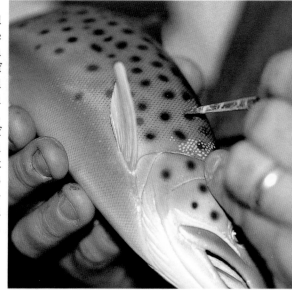

2

Stenciling a Scale Pattern
with Rick Roth

Trout have very small, fine scales, and rather than carve each one separately, Rick Roth uses a stenciling method. In this demonstration on a scrap piece of tupelo, Rick shows how he stencils scales with a piece of netting like that used for bridal veils. (This method was used on the brown trout he painted in the last chapter.)

The first step is to seal the surface of the wood, which Rick does with Krylon #1311 matte finish. The fish is then painted with two coats of brown gesso, which Rick has darkened by adding black umber.

When the gesso has dried, Rick applies the veil material to the wood surface using a spray adhesive. The netting comes in a variety of sizes and patterns. "You have to look around for a pattern that matches the scales you're doing," he says. "The brown trout has roundish scales, and the brook trout's scales are more triangular. This method works well for fish that have very small scales. If I'm doing a fish that has larger scales, I carve them."

Rick does one side of the fish at a time, pressing the material into the contours. It's important that the netting be in contact with the wood surface. To simplify the process, the scales are applied before the fins are inserted.

Once the netting material has adhered to the surface, Rick stencils the scales using water-based Wasco Polytranspar super-hide white taxidermy paint applied with an airbrush. The extreme top and bottom of the fish are masked with tape when Rick paints. The back of the fish will be very dark, and the belly will be very light, so scales will not show in these areas.

After Rick paints the fish, he will finish it with a technique called scale-tipping, in which he will apply a small dab of silver pearl essence to the center of each scale. "The reason I do the scaling is to have a guide to go by when I scale-tip the fish," he says. "This technique creates even, uniform scales. When you try to freehand the scales you sometimes get tired and wind up getting bigger scales when you get close to being finished. This way, you have a nice guideline to use and the process is quick."

Rick stencils the scale pattern with super-hide white and then removes the netting almost immediately, letting the paint set for just a few seconds.

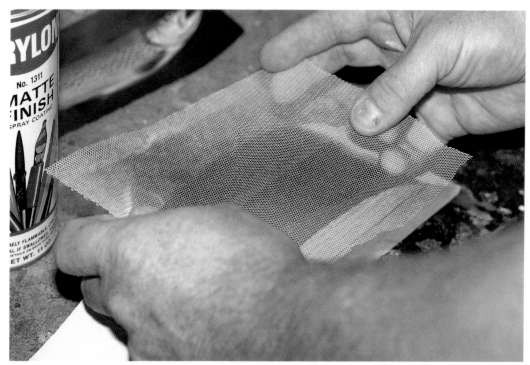

Bridal veil netting is laid over a surface prepared with brown gesso.

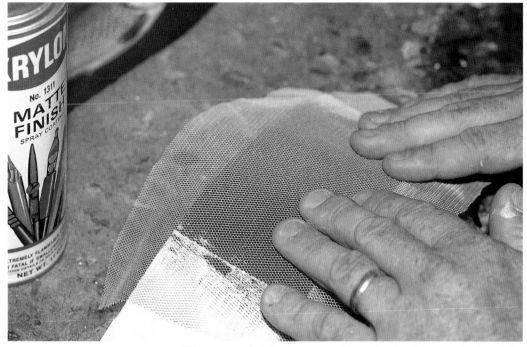

The material is temporarily attached to the fish with a spray adhesive. The netting should be pressed into contours to maintain close contact.

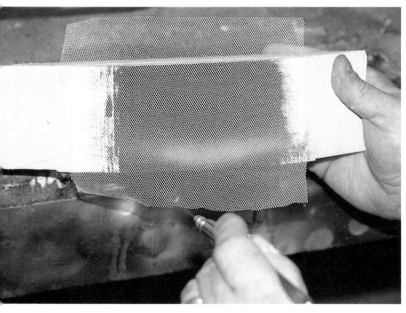

Super-hide white is used in the airbrush to paint the material.

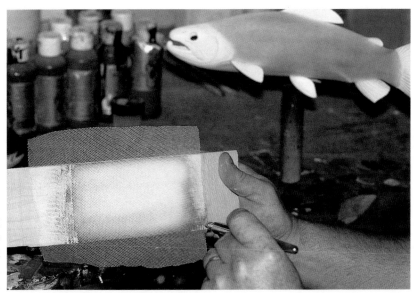

The netting should be painted until it is a uniform white.

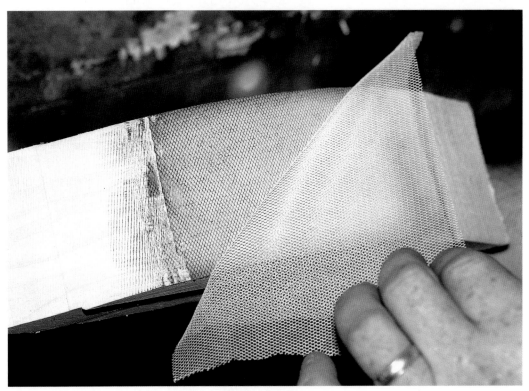

Rick allows the paint to dry for a few seconds, and then pulls away the material to reveal a stenciled scale pattern. The process works well only with fish that have fine scales, such as trout.

3
Kevin Currier

Painting a Brook Trout with

For Christmas 1989 Kevin Currier decided he was going to carve a duck for an uncle. He had studied graphic arts in college and had done quite a few paintings on canvas, but he had very little experience with sculpture and had not worked with wood at all. He bought some Japanese chisels and a block of pine but was at a loss when it came to finding good reference material. Christmas came and went and Kevin had not carved the duck for his uncle.

Then in January Kevin went ice fishing near his home in Pembroke, New Hampshire, caught a bluegill sunfish, and was suddenly struck with the idea of carving the fish. "I really thought, when the idea came to me, that no one had ever thought of carving a fish before," he says. "I was convinced I was a pioneer and was on to something new. I didn't know of anyone who carved fish and had never seen a carved fish."

So Kevin set up shop in his attic and in two nights carved the bluegill. "I had been painting on canvas for years, and I thought that if I could just get through the carving process, painting would be easy. Well, I carved the fish in two nights and it took me two weeks to paint it. I repainted it every night after work, and I never did get it quite right. I was using brushes and tube oils, and by the time I carved my second fish I realized I needed an airbrush."

To his surprise, Kevin discovered that there was a market for his carved fish, and he began taking orders. He bought an airbrush and began carving trout, salmon, and sunfish. "I always liked the shape and color of trout," he says. "When I was doing paintings and taking art classes I would often include a trout in

a still life. When I began carving, I didn't consider what I was doing as art. I was just making a wooden fish and mounting it on a metal rod. But gradually, I guess there was a merger of art and craft in my mind, and design and composition have become very important. I also discovered that there were a lot of other people out there carving fish, and I began to enter some of the competitions and shows and learned a lot from other carvers."

The brook trout is one of Kevin's favorite fish, and it is the subject of this painting demonstration. "I enjoy carving fish that I like to fish for, that are part of this area of New Hampshire," he says. "And my customers feel the same way about the fish they want to collect. That means Atlantic salmon, landlocked salmon, lake trout, smallmouth bass, and primarily brook trout. Ninety-five percent of the trout I do are brook trout."

Kevin uses an airbrush loaded with Wasco Polytranspar water-based taxidermy paints, which come in premixed colors tailored to various species of fish. He uses two airbrushes, a Pasche for general use and a smaller Aztec for detail work. Small artist's brushes are also used for fine detail.

The fish has been carved from basswood and textured with a high-speed grinder and burning pen. Kevin is just completing texturing the fins as this demonstration begins. Before painting, he seals the surface of the wood with Krylon Crystal Clear Acrylic

Before painting the brook trout, Kevin adds some fine detail in the facial area with a burning pen. The gill covers, the mouth, and the spiny rays of the fins are detailed in this manner.

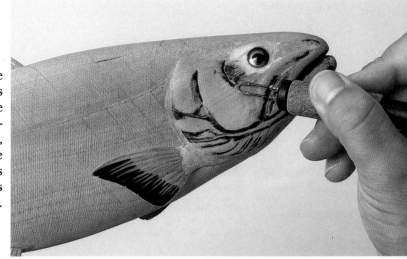

Coating, and then applies white gesso diluted one-to-one with water. Gesso acts as a primer, providing a uniform painting surface for subsequent applications of color.

For information on Kevin Currier's fish carvings, contact him at 18 Maple Street, Pembroke, NH 03275.

The fins are carved separately and are inserted into the body of the fish. The rays of the fins are carved with a high-speed grinder, but the finer detail is carved with the burning pen. Kevin adds some final detail before painting.

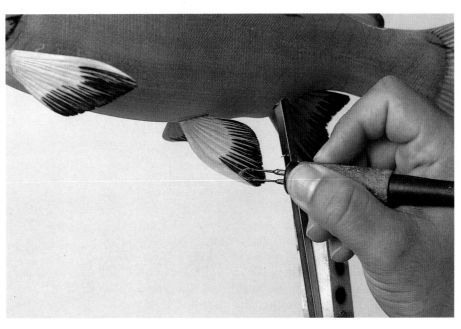

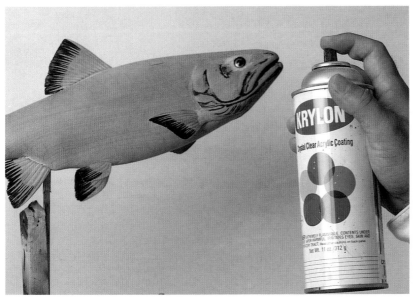

Kevin seals the wood with a spray sanding sealer, in this case Krylon Crystal Clear Acrylic Coating. The coating seals the fibers of the wood and provides a uniform painting surface.

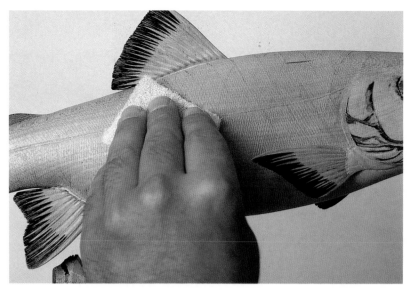

Sanding sealer sometimes will raise the grain of the wood. Kevin uses a fine 3-M sanding pad to smooth the surface and remove any fibers or imperfections before painting.

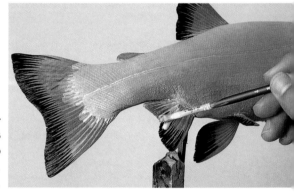

Painting begins with an application of watered down white gesso, which serves as a primer coat. Kevin dilutes the gesso one-to-one with water and brushes it on. The airbrush could be used as well.

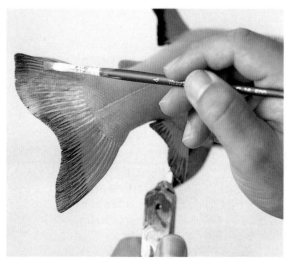

Kevin prefers to keep the gesso watery to avoid buildups that could obscure the carved detail. He usually applies two thin coats to the entire surface of the fish.

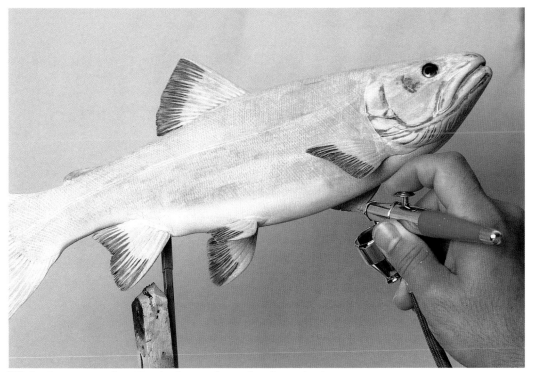

With the gesso dry, Kevin is ready to begin painting
with the airbrush. He begins by painting the belly of
the trout with a color Wasco calls Bass Belly White.
Titanium white tinted with a little yellow ocher
would be similar.

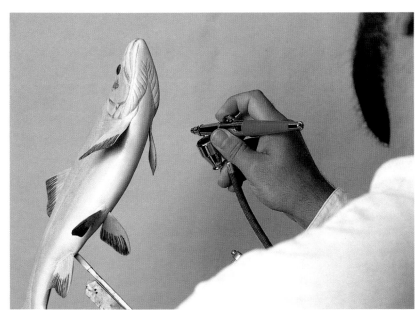

The white is
applied along
the belly of the
fish, on the bot-
tom of the jaw
to about one-
fourth the way
up the head,
and from the
base of the
lower fins to
the tail.

23

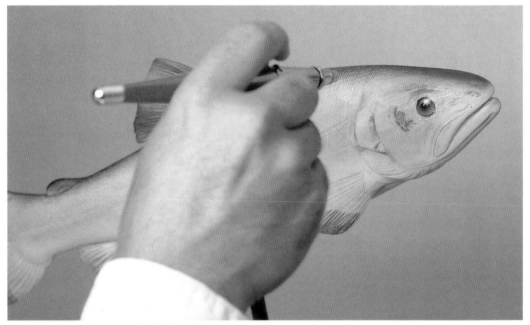

The back of the trout will be dark green, but before
applying the green, Kevin darkens the area with
gray, made by adding black to the white paint he
just used.

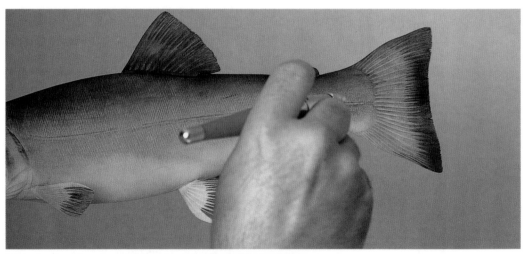

The darkest areas of the trout—the ridge of the
back, the top of the head, and the top fins and cau-
dal fin—will be darkened. The caudal fin is darkest
along its outer perimeter.

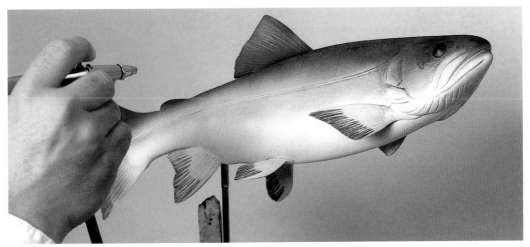

The dorsal and adipose fins are darkened with gray, which later will be covered. The gray comes about halfway down to the lateral line, and Kevin uses the airbrush to create a soft edge. The dark base coat will make later applications of green seem deeper and richer.

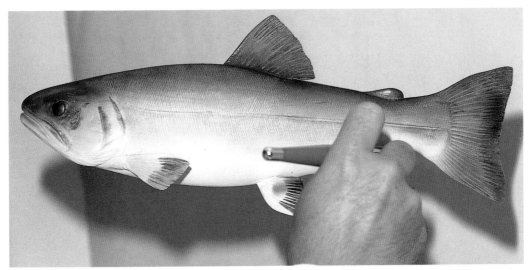

With the base coats of white and gray dry, Kevin adds the first actual color, yellow ocher, which has been brightened by adding cadmium yellow at a ratio of about one part to four. Kevin begins at the tail of the fish, applying yellow over the gray and blending it into the white.

The yellow will serve as a base color for green on the upper parts of the fish and orange along the flanks. It is applied to the head, down to the jawline, and along the back and sides. Unlike tropical fish, trout have no hard delineations of color. Edges should be soft and gradual; the airbrush is a handy tool for accomplishing this.

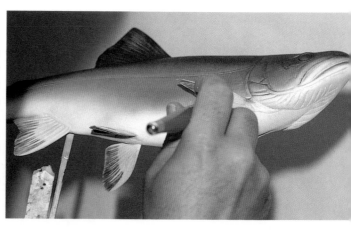

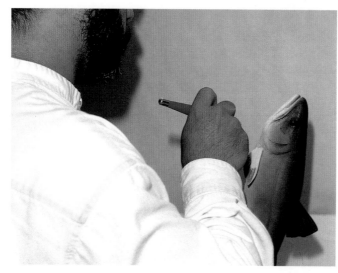

Next, Kevin sprays a thin wash of iridescent silver pearl over the yellow. The silver pearl will tone down the yellow and will add some natural-looking iridescence when light hits the fish.

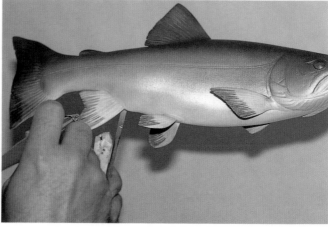

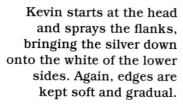

Kevin starts at the head and sprays the flanks, bringing the silver down onto the white of the lower sides. Again, edges are kept soft and gradual.

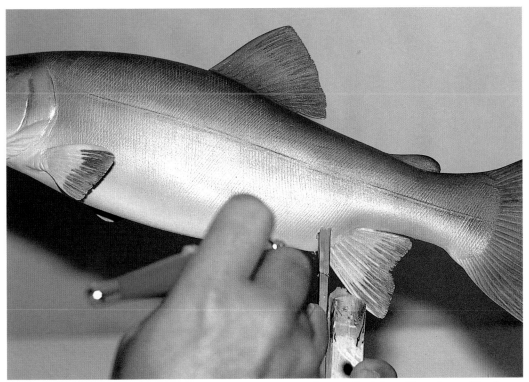

Transparent orange is applied in a line from the base of the pectoral fin, over the pelvic fin, and to the anal fin, where it fades out. This is a very light color, and the effect should be subtle.

Shimmering blue is another iridescent paint that helps create the complexity of colors along the flanks of the trout. As with a real fish, the colors should change slightly as the direction of light changes when one looks at the carving. Shimmering blue is sprayed in a fine mist along the sides and onto the gill plates.

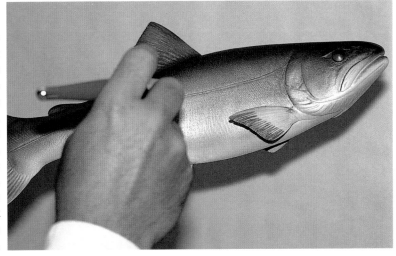

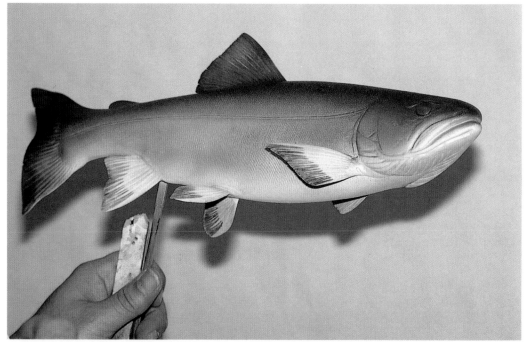

Kevin's mounting system allows him to hold the fish at various angles while painting it. A square brass rod is inserted in the body of the fish for painting and will also be used to mount the fish on its base when it is completed. The rod fits into a brass sleeve, which is clamped to a stand. Using a square rod prevents the fish from turning on the mount.

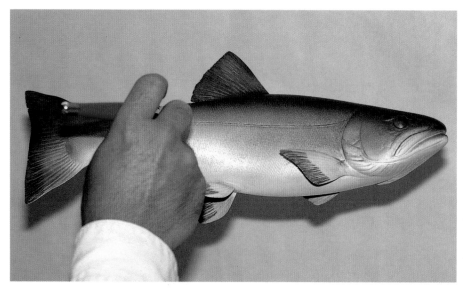

Kevin sprays light transparent green from just above the lateral line over the back and on the top of the head.

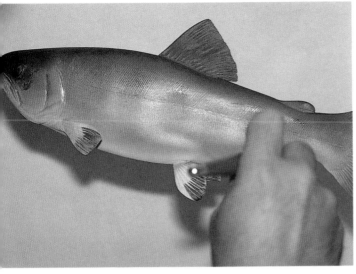

Young trout have parr marks along their sides, and because this is a small fish, Kevin wants to add a hint of these vertical oval bands. He does this with the transparent green, being careful to keep the edges soft.

To paint the parr mark, Kevin aims at the lateral line and moves the airbrush in an oval. These marks should be subtle, but adding them helps break up the broad areas of iridescence on the flanks. The ridge of the back is darkened also at this time.

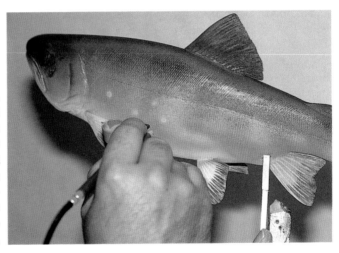

The trout is covered with irregular yellow, red, and blue spots. Individual fish differ in the size and shape of the spots, but in general the yellow spots and squiggles are in the upper areas and the blue spots are in the lower portions. There are small individual red spots, and some blue spots have red centers. Kevin will begin with the blue spots along the sides and lower flanks of the trout.

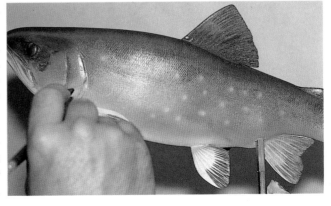

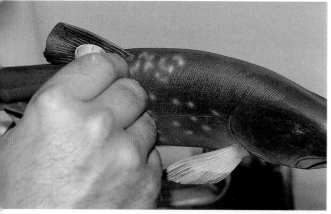

The spots should have soft edges, and Kevin adjusts his airbrush accordingly, practicing on a piece of paper before painting the fish. The blue is made of a mix of three parts white and one part cobalt blue. The blue spots begin behind the gill covers and go to just beyond the anal fin. They extend from the orange area near the belly to about halfway between the lateral line and the back.

The vermiculated yellow pattern on the back and the yellow spots are painted with yellow ocher to which has been added a small amount of white to gain opacity.

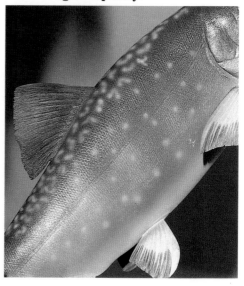

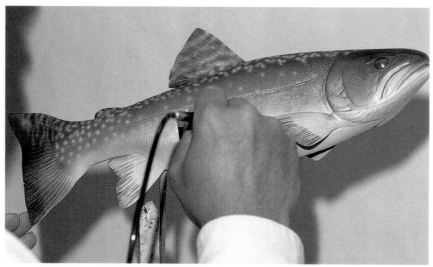

The markings on the back of the fish consist of random, wormlike patterns. The dots on the sides of the fish are roundish and are approximately the same size as the blue spots.

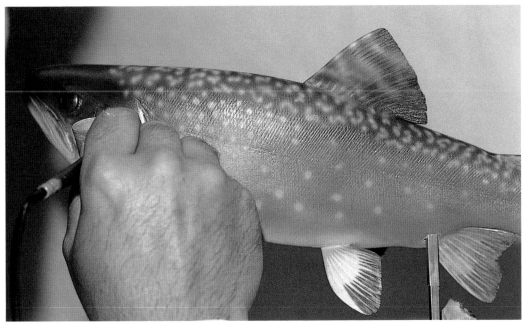

On the sides, the yellow spots are intermingled with the blue ones. A small amount of yellow is added to the centers of some of the blue spots. Vermiculated marks go on the dorsal fin and the top of the caudal fin.

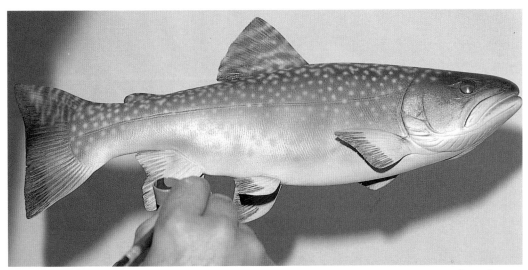

A line of red is applied along the lower flanks where the orange meets the white of the belly.

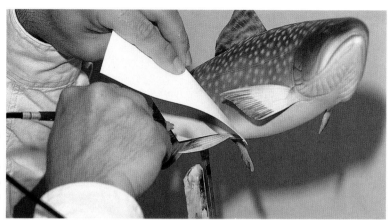

Red is now sprayed onto the lower fins, and Kevin uses a piece of light card stock to mask the fish as he paints.

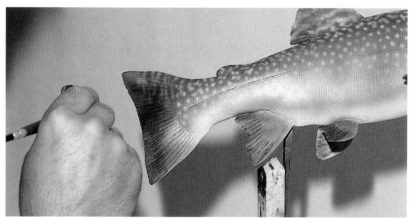

After applying the red, Kevin deepens the color value by misting on a small amount of transparent violet. Violet is a strong color, and Kevin is careful to apply only a light wash.

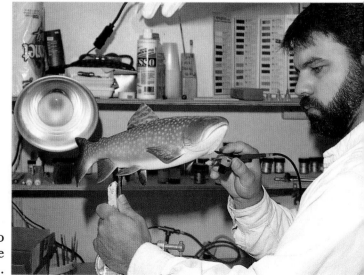

Red and violet are applied to all the lower fins, and to the lower parts of the caudal fin.

On a large fish, Kevin will use his airbrush to apply the red dots to the centers of the blue marks. But as this is a small trout, he uses a small artist's brush instead, dabbing just a small amount of red in the blue circles. He is using Wasco gill red, which is similar to red oxide.

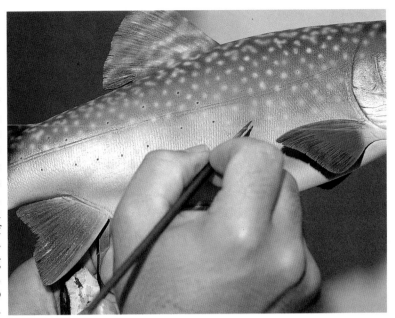

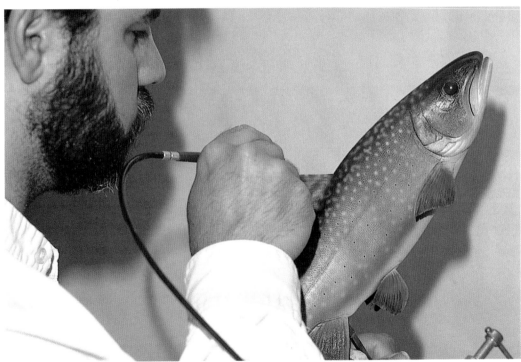

Medium bass green is sprayed on the top of the back to darken it and to tone down the vermiculated pattern. The top of the head also is darkened with this color.

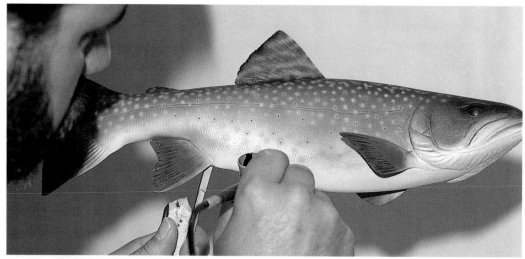

Kevin adds black to the green in the airbrush cup and further darkens the back of the trout. He then paints a faint black line beginning behind the pectoral fin and extending rearward to just above the anal fin.

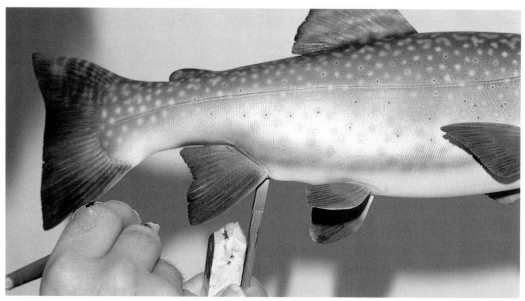

Kevin now applies straight black to the leading edges of the lower fins and to the lower part of the caudal fin. There should be no green remaining at this point.

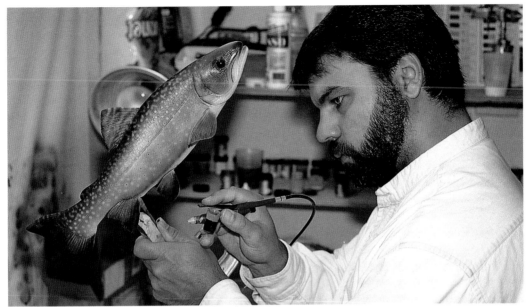

The rays of the pectoral, pelvic, and anal fins are painted straight black. Later, a white line will be applied to the leading edges.

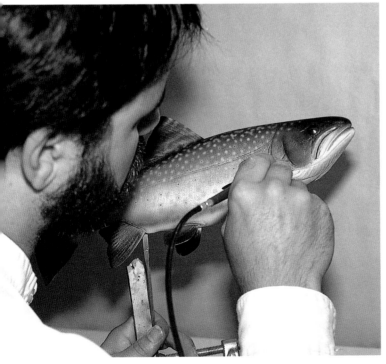

The same black is used to define detail in the facial area. Kevin paints contours around the gill plates and edges the jaw with black, helping to emphasize shadows.

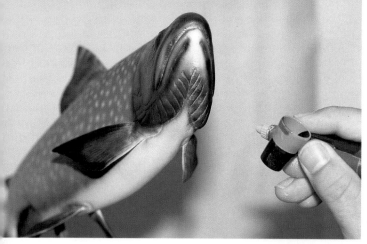

Black is sprayed onto the gill plates and the area under the jaw.

Kevin cleans the black from his airbrush and sprays a fine mist of gold toner over the fish. The paint is a satin sheen gloss to which gold pigment has been added. This helps blend bright colors and serves as a foundation for building up a glossy look in the finished fish.

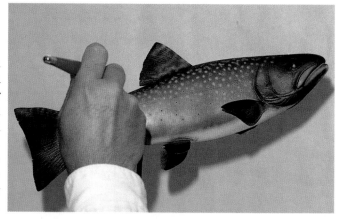

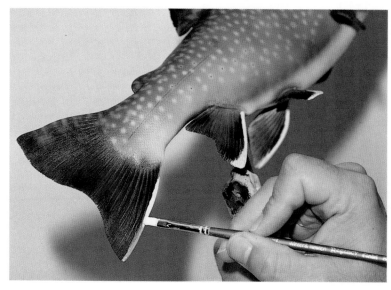

After the gold toner goes on, Kevin uses a brush to paint white on the leading edges of the lower fins. The front edge of the fins should be white, with a gradual blending into black on the back edge.

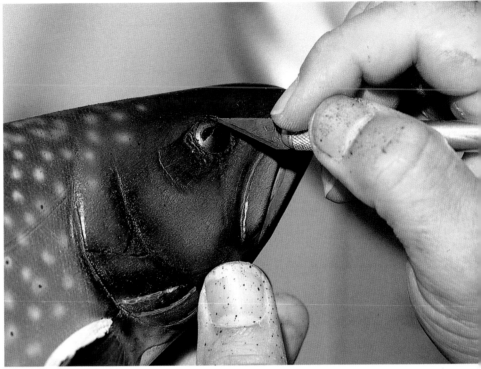

Kevin uses a knife to scrape paint off the glass eye. Care must be taken not to scratch the eye.

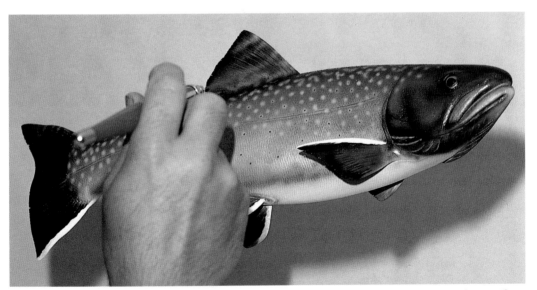

The final step is to apply satin sheen over the entire fish. This provides a slight gloss and seals the surface of the fish.

The fish will be mounted on a pedestal of stone, which in turn will sit on a wooden base. The stones shown here are a combination of carved tupelo and wood putty. The stones are primed with gesso and then painted with three shades of gray tube paint.

Kevin uses gray and black paint with a toothbrush to flick on color, creating a speckled look.

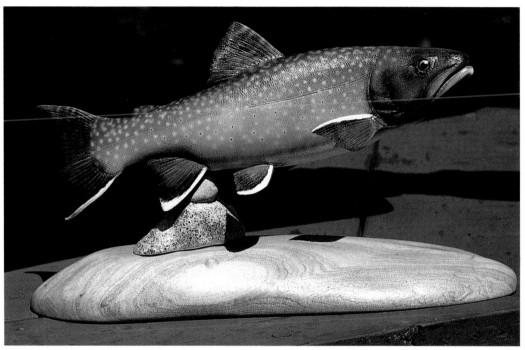

The finished brook trout, with its granite and wood base.

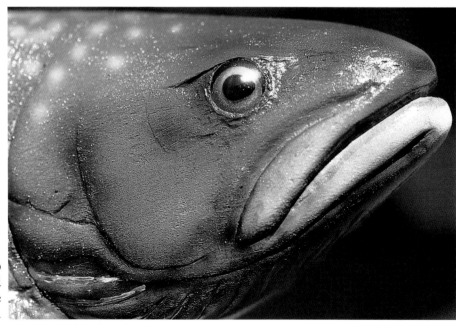

Close-up shows detail around the eye and mouth.

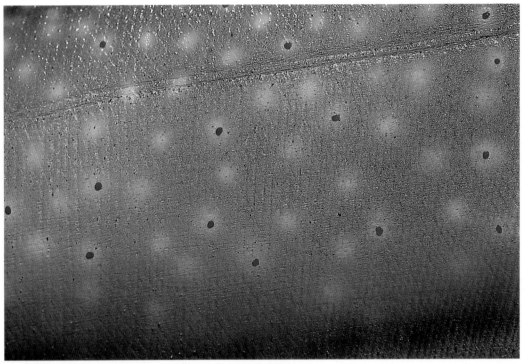

Note the pattern of yellow, blue, and red dots on the flanks.

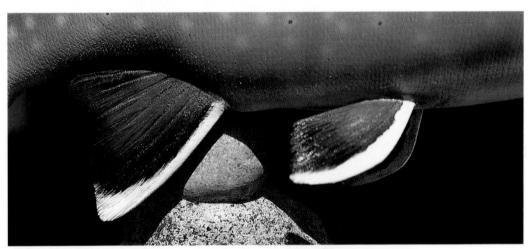

Male brook trout have an opaque white leading edge on the lower fins. The white edge should be feathered slightly on the trailing edge, as shown here on the anal fin.

4
Carving and Inserting Fins
with Clark Schreibeis

One of the most demanding aspects of fish carving is the making and insertion of fins. Done right, fins create the illusion of motion and life; they become part of a flowing, visually pleasing composition. Done wrong, fins have the look of an unneeded appendage haphazardly attached to the fish.

The purpose of this demonstration is to show you how to do fins right. Clark Schreibeis of Billings, Montana, is a fisherman, taxidermist, and fish carver who has spent most of his adult life studying trout. He also is an artist and meticulous craftsman who knows that a fish carving is only as good as the fins that are attached to it. The fins, after all, bring the fish to life.

Clark has won numerous national awards for both taxidermy and fish carving, and his unique method of fin carving and insertion is the main reason why. He carves and paints the fins before inserting them into the body of the fish, and thus is able to mount the fins in a wide variety of attitudes and to paint them more accurately than if they were inserted before painting.

Fins should be carved with compound curves to provide the illusion of motion, Clark believes, and they should often be carved at an angle to the plane of the body of the fish. They might even overlay the body slightly, as does the dorsal fin that is carved in this demonstration.

Fins should also appear to be an extension of the body of the fish, not simply an attachment, says Clark. After all, fins propel and maneuver the fish, and they are attached to muscle tissues and nerves that control them.

To accurately carve fins, Clark depends on good-quality reference material. He uses photos he takes on fishing trips, and he has a file of photos clipped from magazines. Plastic casts taken from freshly caught fish are invaluable in determining accurate fin layout and detail. And there is nothing to compare with time spent at an aquarium watching fish and learning how they use their fins.

Field research is a pleasurable activity in Montana, a state where trout fishing is a top outdoor sport. Clark frequently breaks away from his studio to check on the native trout in the rivers of Montana's wilderness areas. Indeed, it was a fishing and canoeing trip to Alaska several years ago that got him started in fish carving.

"I've always enjoyed the outdoors, but on the trip to Alaska I decided to find a way to make a living doing it," he says. "I had the idea of going into taxidermy, thinking that would keep me outside a lot, which turned out not to be true. But I think that trip is what convinced me that in some way I wanted to work with fish and wildlife."

The trip took place in the summer of 1980. Clark was twenty-five and single, and he and a group of friends spent nearly five months exploring Alaska wilderness, canoeing four different rivers. Shortly after returning to Montana, Clark and his girlfriend, Rika, were married and Clark set up a taxidermy shop in the garage, still working in the construction business to keep the bills paid.

In 1985 Clark quit the construction business to devote his time to taxidermy. He went to the World Taxidermy Championship in Kansas, his first competition. He picked up a third-place ribbon in the commercial division and attended a fish carving demonstration by Bob Berry of California. "Bob carved a little brown trout in two hours and then passed it around the room," says Clark. "I was really impressed with it, and I was determined to try carving. There were some carving supply dealers at the show, and I went out and bought a Foredom and a bunch of other tools and brought them home."

Unfortunately for his carving career, Clark was winning a reputation as a taxidermist, as an interest in competitions pushed his work to a higher level. His

taxidermy workload kept the carving tools on the shelf.

And then one day Clark's friend, Bill Seidl, a fellow taxidermist from Billings, showed up at his shop with a brown trout carved from cottonwood, and the fire to carve was relit. "It was right at the time Bob Berry's book [Freshwater Fish Carving] came out," says Clark. "I read it cover to cover and carved a brown trout, and I entered it in a taxidermy competition we have here called the Battle of the Mounts. The carved fish won best in show, and I wanted to do more."

The taxidermy business was keeping Clark busy, but in 1989 and 1990 he managed to work in several fish carvings. "My second fish was a golden trout, and Bill and I went to a fish carving competition in Traverse City and entered. He had carved a brown trout, which we both thought was better than my golden, but my fish won best in show, although to this day I don't know why."

The wins encouraged Clark to spend more time carving, and soon collectors began offering commissions. He still is involved in taxidermy, but carving is taking an increasing amount of his workweek.

For information on Clark Schreibeis's fish carvings, contact him at 5626 Danford Road, Billings, MT 59106.

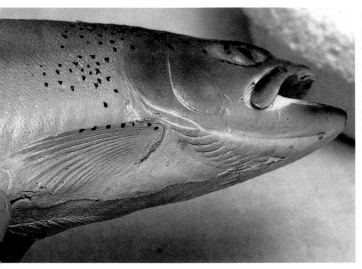

Trout have the ability to move their fins through a wide variety of attitudes, and they can fold them tightly against their body to become more streamlined. Look closely and you will see a small shelf where the fin joins the body and a slight depression for the fin to fit into when the fish presses it against its body. To most accurately depict this quality in a carved fish, the fins should be carved, textured, and painted before being mounted on the body.

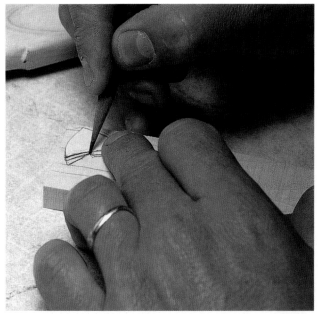

Clark begins making the fins for a six-inch miniature cutthroat by tracing the pattern onto a piece of half-inch tupelo stock. Wood grain should run with the length of the fin to improve strength. A tongue will be carved on the fin that will fit into a slot carved in the body of the fish.

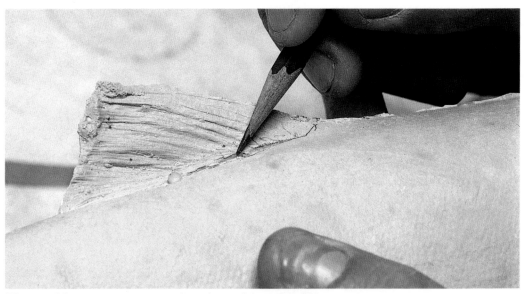

The problem many carvers face is making the fins appear as an extension of the fish's body, not as a haphazardly attached appendage. Good reference material helps with this. Look closely at this casting, and you will see a ridge of tissue where the dorsal fin joins the body; adding this ridge will make the fin appear to be part of the body.

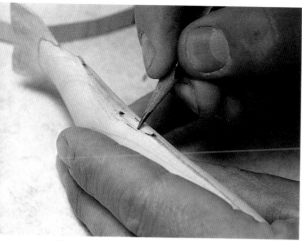

Clark uses the burning pen to scribe the margins of the slot. The burned marks serve as a guide and are not cut deeply. The techniques for carving and inserting the anal and dorsal fins are similar, so Clark likes to do them simultaneously.

Clark's technique is to carve in the body of the fish a slot in which the fin will be fitted; its size is determined by the width of the ridge on the dorsal fin. The fin will overlay the body, making it appear more lifelike. A pencil is used to sketch the location of the dorsal fin. Clark warns carvers to avoid using taxidermy mounts as reference because the tissue at the base of the fin is often dried out and not visible. Castings made from fresh fish are best.

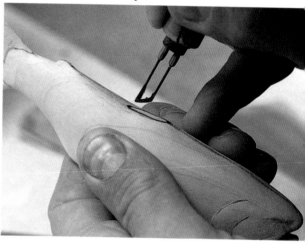

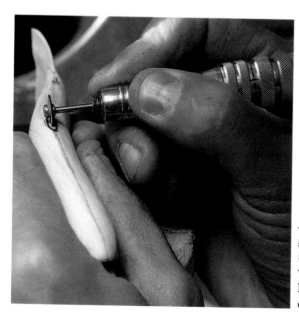

A cutting disk on a high-speed grinder is used to rough out the slot. Clark begins in the center and works outward toward the burned lines. The slot is approximately one-eighth inch deep.

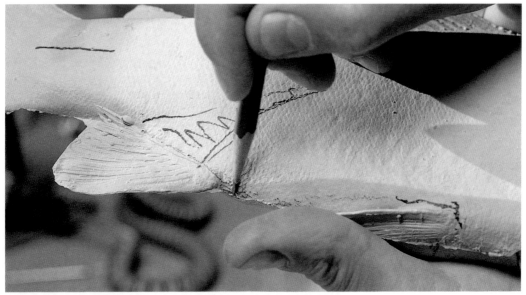

A reference casting shows that the anal fin and anal opening are on the same plane. The body line turns just before meeting the anal fin, and the anal opening is just behind the turn. The opening should be angled to the rear of the fish, not downward.

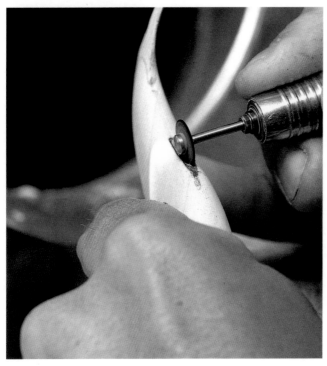

The same disk is used to rough out the anal fin slot.

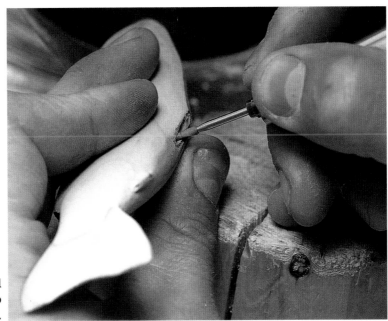

A tapered diamond cylinder is used to clean out the slot.

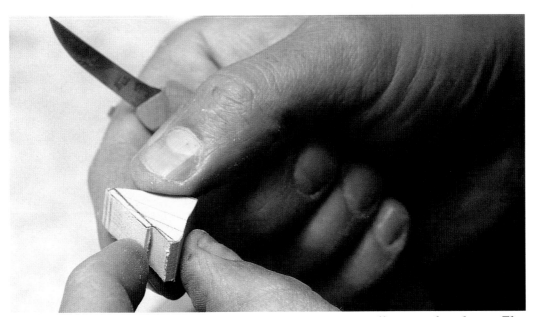

The fins are cut out on a scroll saw or band saw. The half-inch stock is necessary for two reasons. Clark wants to include the width of the connective tissue with the fin, and he also will curve the fin slightly. Thinner stock would limit him in both these areas. The extension on the bottom of the fin is the portion that will fit in the slot.

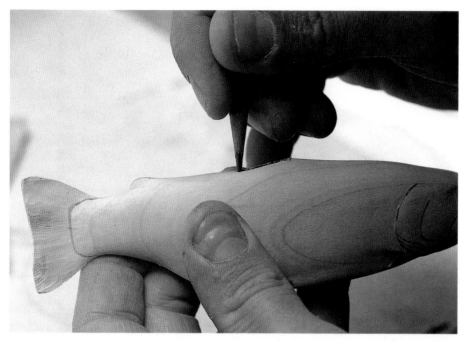

To ensure a
precise fit,
Clark uses a
soft lead pencil
to coat the slot.
When the fin is
test-fitted, areas
that pick up
lead will be re-
duced further.

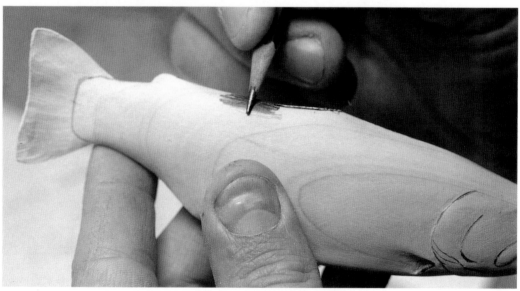

The same technique is used where the dorsal fin will
overlay the body of the fish. The fin will be offset to
the right and will be folded slightly across the body.
As the fin is fitted, wood will be removed where it
picks up lead.

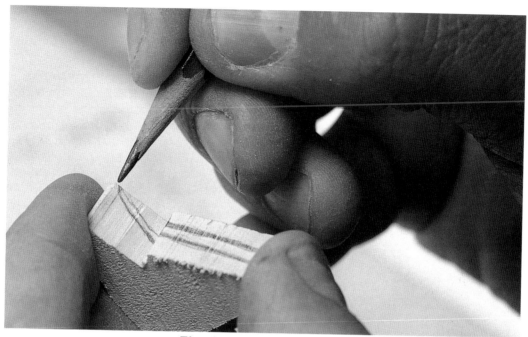

The dorsal fin will be carved with a compound curve. The marks on the right (on the tongue) correspond to the slot cut in the body of the fish. The marks on the left depict the angle at which the fin will be offset.

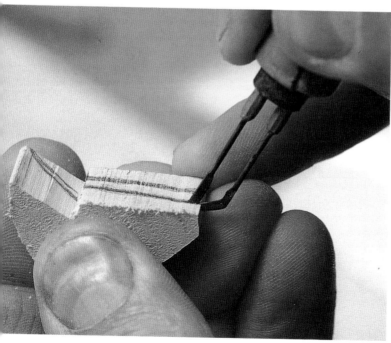

The burning pen is used to carve the tongue.

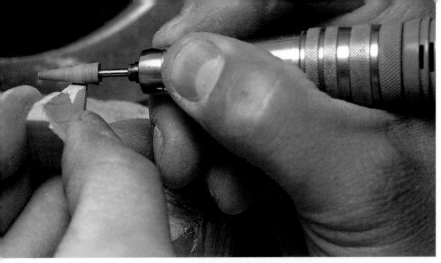

Preliminary shaping of the fin is done with a tapered cylinder on a high-speed grinder. The tongue will be fitted into the slot before the fin is actually carved.

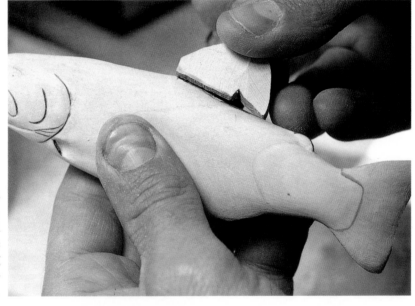

Clark test-fits the dorsal fin, using pencil lead as a guide in determining where to remove wood.

To shape the tongue, Clark uses a diamond cylinder that has no cutting surface on its end. With this tip, he can cut right up to the fleshy part of the fin without damaging it.

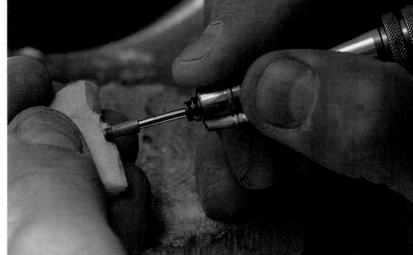

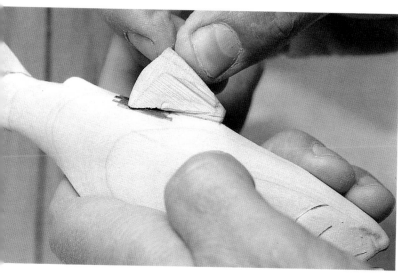

The tongue fits into the slot, and now Clark tests the fit where the fin will overlay the body of the trout. The pencil lead will again indicate where wood should be removed.

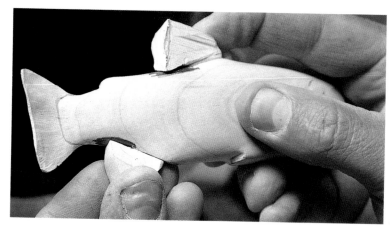

The dorsal fin is fitted into the body of the fish, and now Clark will go through the same process with the anal fin. Pencil lead is used as a guide.

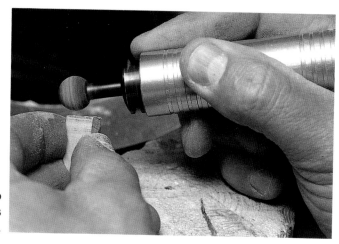

The high-speed grinder is used to carve the tongue, and a notch is cut in the body of the fish.

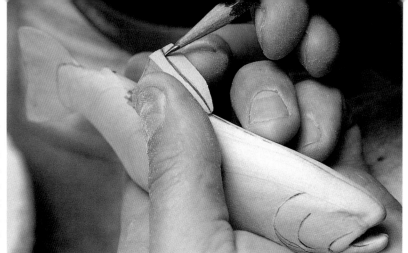

With the anal and dorsal fins fitted, Clark is ready to carve them. The first step is to sketch the layout of the fin, which Clark does here with the dorsal.

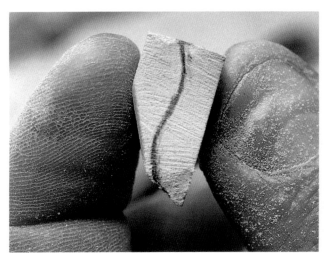

In most cases, the fins should be carved with a curve. The curved line is more pleasing to the eye, and Clark says the fin can be left thicker and stronger when a curve is added. If the fin is carved in a straight line, it must be made very thin.

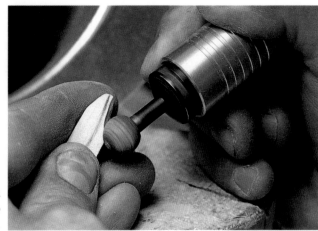

Clark uses a carbide ball on a high-speed grinder to remove wood from the fin.

With the fin roughed out, Clark again checks it for fit. The overall length of a curved fin will be less than if the fin were straight.

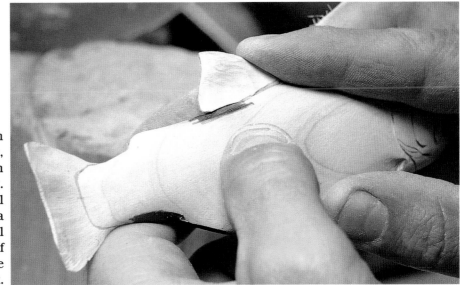

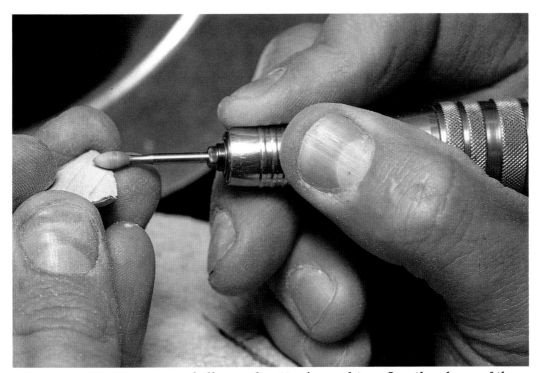

A diamond cutter is used to refine the shape of the fin and to smooth it. Sandpaper in 150-grit is used to finish it.

The curved dorsal fin is complete
and ready for texturing.

Clark repeats the procedure with the anal fin, shap-
ing it with the ball and refining the shape with the
diamond cutter.

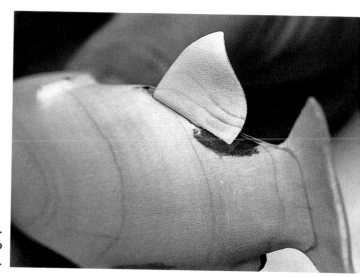

The anal fin is fitted to the body. Clark again uses pencil lead to ensure a perfect fit.

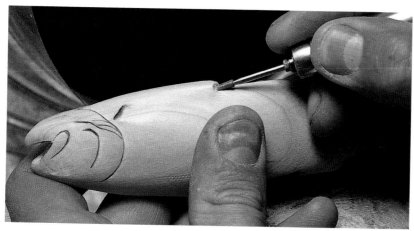

With the dorsal and anal fins carved and ready for texturing, Clark begins work on the two pelvic fins. The fins are inserted into a slot on the abdomen carved with the high-speed grinder.

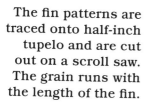

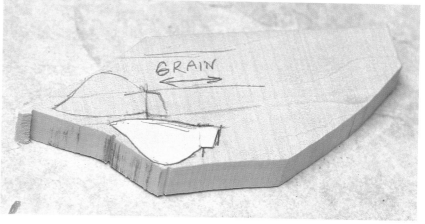

The fin patterns are traced onto half-inch tupelo and are cut out on a scroll saw. The grain runs with the length of the fin.

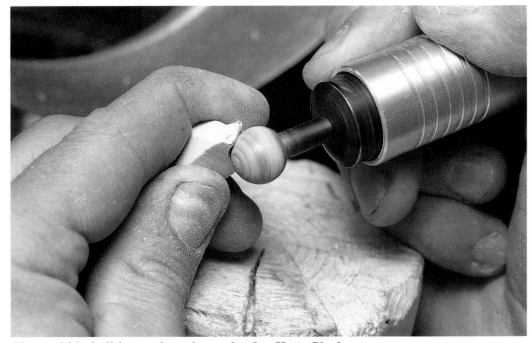

The carbide ball is used to shape the fin. Here Clark
carves the tongue that will be fitted into the slot on
the abdomen of the trout.

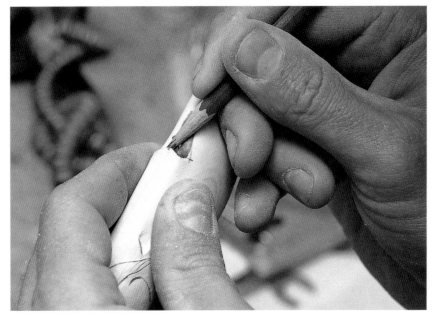

As with the anal
and dorsal fins,
Clark uses pencil
lead to help estab-
lish a tight fit.

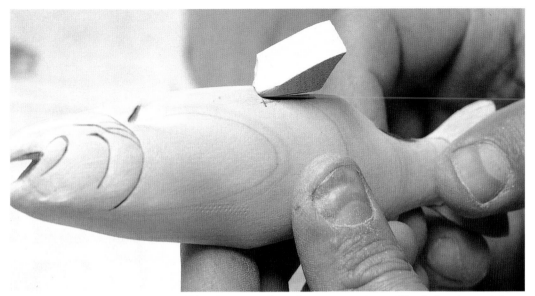

The fins are fitted one at a time. Clark begins with the right fin, fitting it to the body before carving it.

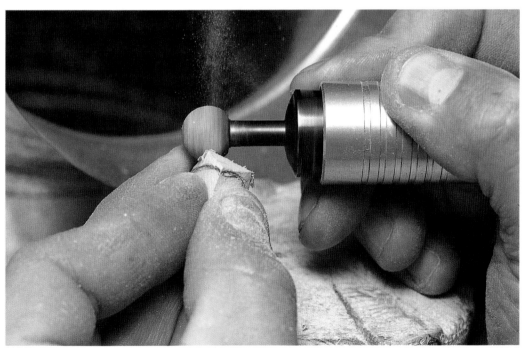

The carbide ball is used for the preliminary shaping of the fin.

Clark refines the shape with the diamond cutter. The pipe is part of a ventilation system that exhausts dust outside.

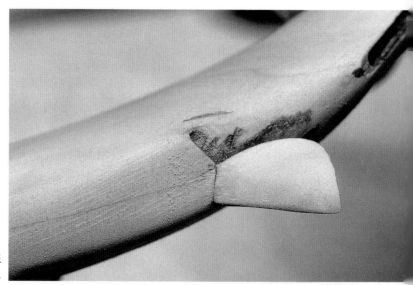

The right fin is roughed out and inserted.

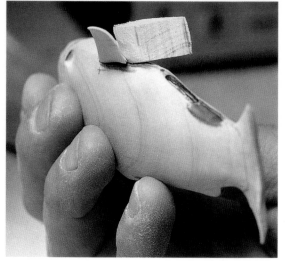

The same procedure is used with the left fin. Clark carves the tongue and fits it to the body before shaping the fin itself.

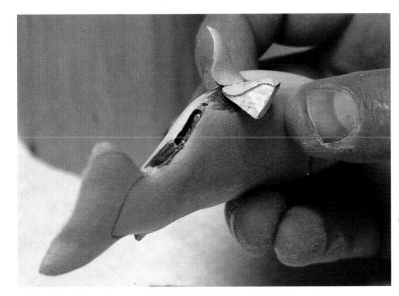

Again, the fin is carved with a curve. The top portion of the left fin has been roughed out here.

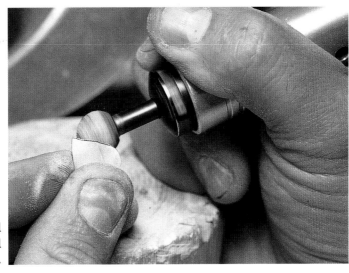

The carbide ball is used to rough out the second pelvic fin.

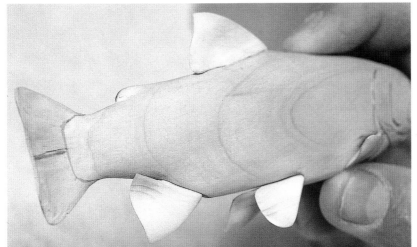

The four inserted fins are now complete and ready for texturing. Clark test-fits them before carving and inserting the two pectoral fins.

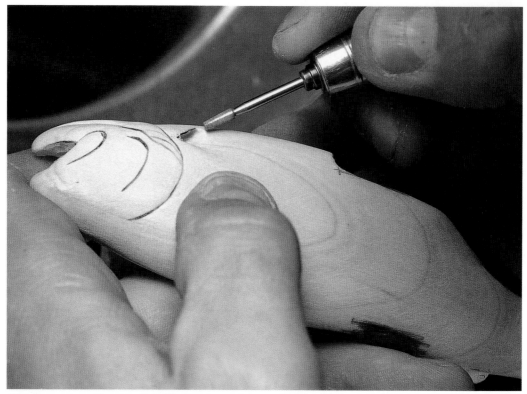

Clark uses a diamond cylinder to cut two slots
where the pectoral fins will be inserted. They are
carved and fitted using the same technique Clark
used with the other fins.

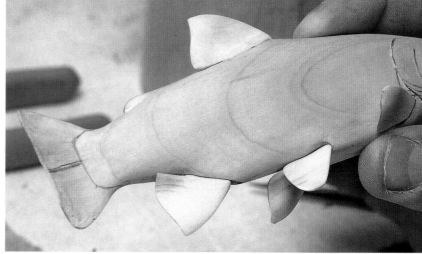

The pectoral fins
have been inserted
and now all six fins
are in place and
ready for texturing.

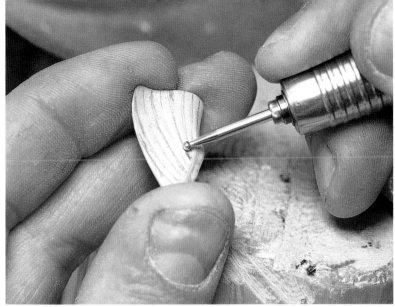

Clark uses a cast taken from a fresh fish as reference when texturing the fins. He sketches the rays with a pencil, with each line representing the trough between the rays. A diamond ball with the grit worn off is used to carve the rays.

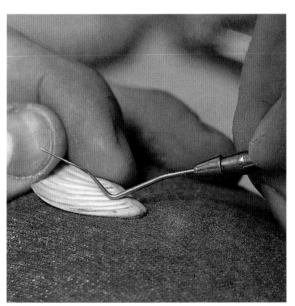

A dental pick is used to smooth the troughs and taper the ends of the rays.

A tool Clark made by sharpening a piece of 9-gauge wire is used to split the rays, creating individual spines. Clark calls it the "broom effect."

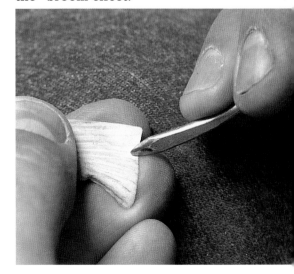

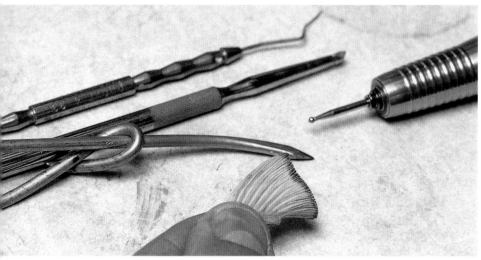

The trailing edge of the fin is dressed up with a burning tool. The edge of the fin is usually not uniform, and the burning pen helps create this feathered effect.

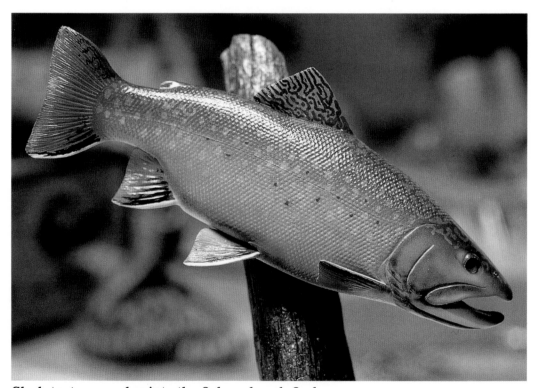

Clark textures and paints the fish and each fin before inserting and gluing the fins with epoxy. The completed trout, mounted on a wooden base, looks like this.

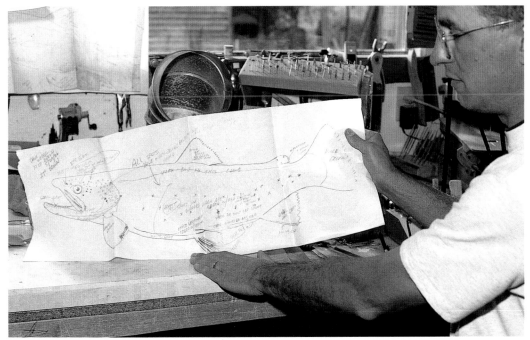

Reference material is invaluable when carving and painting realistic trout. Clark shows a sketch he made of a twenty-seven-inch brown trout caught by a friend. The sketch is used to help with such details as fin location and painting.

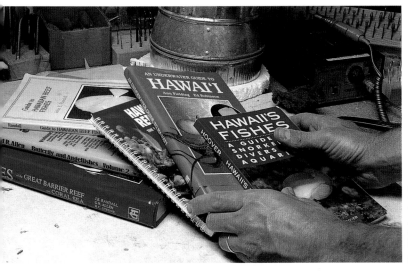

Books provide information not only on the physical appearance of fish but on behavior and habitat as well.

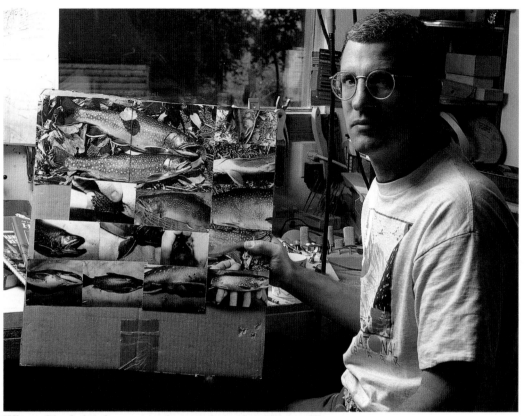

When Clark begins a carving project, he often will mount a number of photos on a piece of cardboard and hang it in his work area.

Photo files cover all the species of fish Clark carves. The best photos are those taken of live fish because the detail and colors are fresh. On fishing trips, the camera always goes in the tackle box.

5
Painting a Steelhead with
Mike Windauer

For Mike Windauer, fishing and art have been life-long passions. The interest in art began when his grandmother started giving him painting lessons at age nine. As he had been fishing since the time he could walk, it was no coincidence that some of his first subjects were fish.

Mike grew up in northwest Montana, so an interest in the outdoors, especially in trout fishing, was expected. But while his interest in fish was a product of his environment, his talent for art was a matter of genetics. His grandmother is a talented artist and his grandfather is a wood carver who specializes in relief work. So when Mike was growing up he was around woodworking tools and art supplies.

His own interest in art began with painting, progressed to taxidermy during high school, and gradually grew to include carving during his college days, when a friend talked him into going to a carving show. "I decided to give it a try," he says, "and I've concentrated on carving for more than six years now. I try to put more and more into each fish I carve, to make each one better."

Mike's talent for art and his interest in fish made fish carving the perfect genre for him, and he has progressed quickly. His work is eagerly sought by collectors, and he has won some of the top competitions in the country. A carving of three steelheads won at the Global Carving Challenge in 1991, and Mike has ribbons from numerous other national and regional competitions.

The steelhead, the sea-run rainbow trout, is Mike's favorite fish, and it is the subject of his demon-

stration here. Mike learned to use the airbrush when doing taxidermy, and that's his instrument of choice, especially when working on a large fish, such as the steelhead.

The fish pictured here is carved from tupelo, and it was sealed with lacquer applied with a foam brush before the base colors were applied.

As the demonstration begins, Mike has sealed the wood and applied three base colors: black on the top and sides, off-white on the belly, and red along the sides. These colors will be covered later and comprise a tonal base—dark where dark colors will go and light were light colors will go.

Mike has also done preliminary scale-tipping on the steelhead. He prefers to scale-tip after the base colors are applied but before the color coats go on. If scale-tipping is done too early in the painting process, it will be covered by subsequent coats. Done when the painting is completed, it will be too prominent. The idea is to have the scale-tipping show but not call attention to itself.

He paints with anything that will do the job. His arsenal includes airbrush paints purchased at local art supply stores, transparent taxidermy paints, lacquers used in the auto body business, felt-tip markers, and cans of spray paint.

He scale-tips and paints the base coat before inserting the fins because he finds that the fish is easier

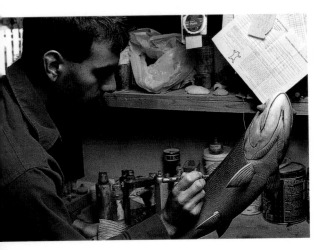

Mike begins the painting process by applying base colors with the airbrush and then scale-tipping the fish with a silver felt-tip marker. The base color is black, which is applied heavily on the back of the fish and then faded out along the sides. The belly is painted off-white, and this is blended into the black along the sides. Mike also applies a line of red along the flanks of the trout. This will serve as a tonal base for a pink stripe that will go on later.

to handle without them. As the demonstration begins, the base coats of black, off-white, and red have been applied and the scales tipped with a silver marker. Subsequent applications of transparent color will make the silver scale tips appear in a range of colors, ranging from green to red.

Modeling clay has been pressed on over the eyes to protect them during painting.

For information on Mike Windauer's carvings, contact him at 1606 12th Avenue West, Columbia Falls, MT 59912.

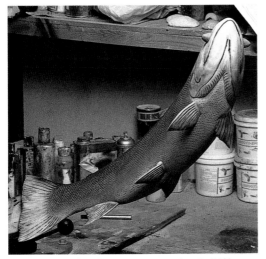

Now that the fins are attached, Mike paints them with a base coat of black to get them near the tonal value of the body of the fish. The trailing edges of the fins are painted a darker value, with a light area left in the center of each fin. Mike uses Life Tone brand airbrush paints for this step.

Varying the tonal values on the fins will help make them appear translucent when color coats are put on later. Note the application of black on the pectoral fin. The fin should be dark on the trailing edge and gradually become lighter near its center.

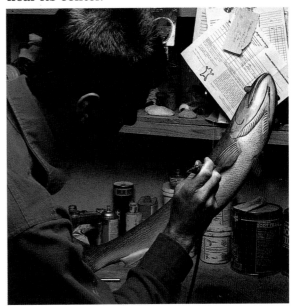

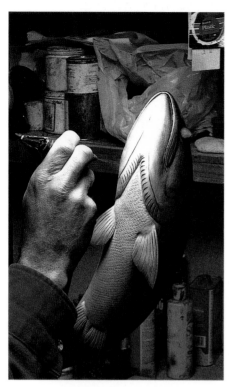

After applying black, Mike loads his airbrush with Life Tone off-white and paints the lower jaw and mists some off-white on the head and the centers of the fins. The head should not be painted a solid color; varying the tonal ranges when applying these base coats will create a softer look when color coats are put on later.

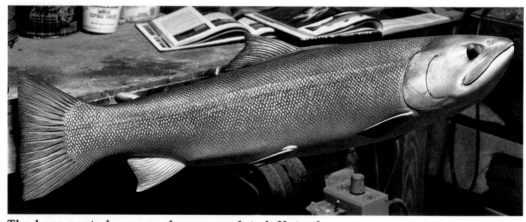

The base coats have now been completed. Note the tonal ranges in the head. The top is dark, the jawline and below are predominantly white, and the area behind the eye has only been misted lightly. Off-white should be applied to the belly until the scale-tipping is barely visible. A light misting of off-white on the dark areas of the head will help subsequent applications of transparent green to show up. Green applied over straight black will appear black.

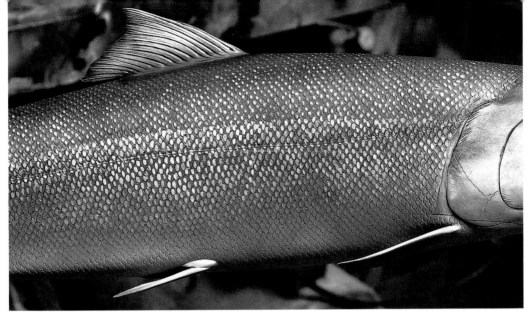

This close-up shows the base colors applied to the dorsal fin and the flank of the steelhead. Note especially the scale-tipping technique. The back of the fish is darker than the sides, and there is a fairly distinct border between light and dark just above the lateral line. This line was created by tipping the scales in the dark area with smaller dabs of silver; scales in the lighter area got larger dabs. Mike also retips a few scales at this point to highlight them and avoid a uniform appearance.

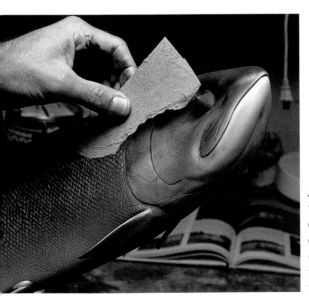

And now Mike is ready to apply the first detail coat, which will be the distinct, irregular line separating the dark top of the head from the light cheek area. To duplicate this line, Mike uses a piece of ragged cardboard as a template.

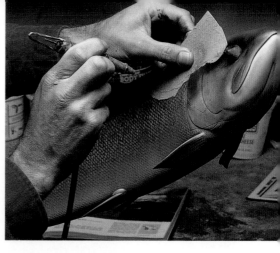

The cardboard shields the top of the head as Mike sprays silver on the area below the line. This part of the gill cover is very reflective, and he uses Duplicolor Instant Chrome aerosol spray purchased at an auto supply shop. The chrome paint is sprayed into the cup of the airbrush and then applied.

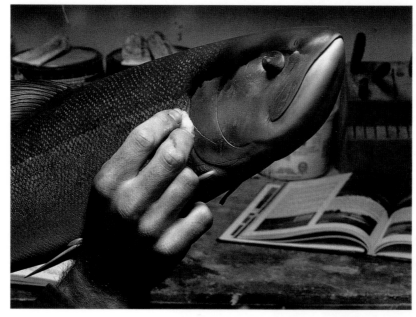

After spraying the gill cover, Mike uses a small sponge to give the paint some texture.

Chrome begins at the dark line above the eyes and extends down the gill covers to the white of the jaw. Mike also mists the flanks of the fish to give them some reflectance. A small amount of Life Tone gold is dabbed onto the bottoms of the gill plates.

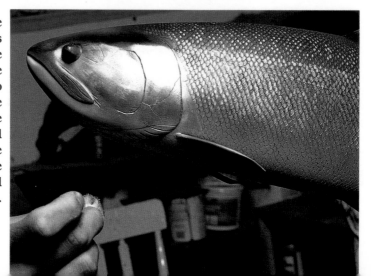

A light pink line runs along the sides of the steelhead. Mike established a foundation for this color by spraying a light red line when he put on the base colors. Now he applies a fine mist of transparent red and silver pearl essence. The coat should be thin to avoid obscuring the scale-tipping. Mike uses about one part Wasco Polytranspar transparent red to three parts silver pearl.

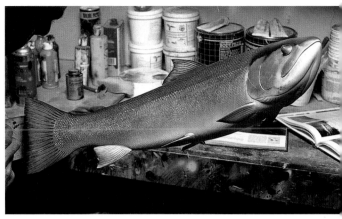

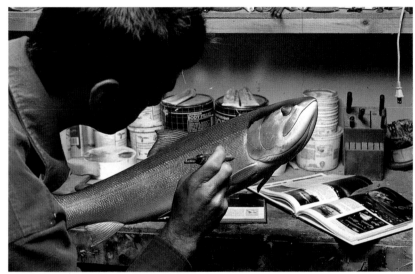

A light mist of pink is sprayed on the gill covers. A spawning steelhead would have deep red sides and gill plates.

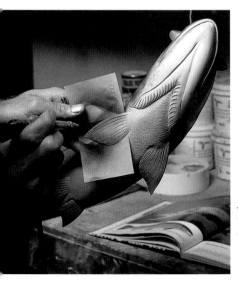

A piece of cardboard is used to mask the body of the fish, and a faint misting of pink is sprayed on the fins to give them a slightly fleshy look.

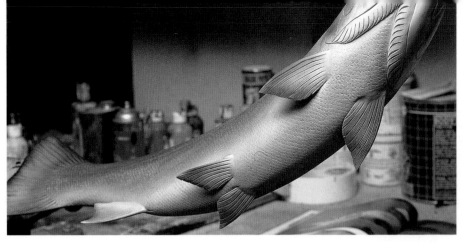

The fins should be white with a pinkish cast in the centers, and dark along the edges.

A little blue is added to the red and silver pearl mix to create a purple value. A fine mist is painted on the sides of the gill plates.

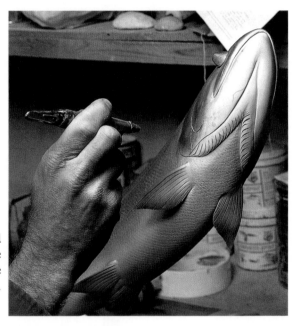

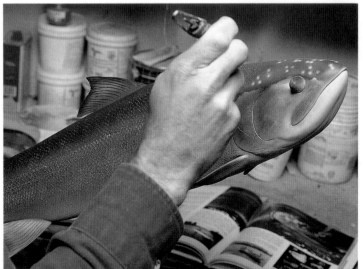

The dark spots on the top of the head are surrounded by a thin halo of light green. Mike paints them by first spraying a series of white dots. The dots should have soft edges.

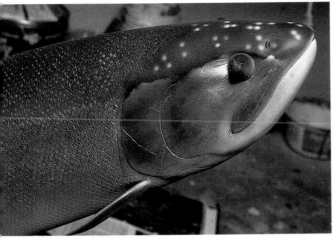

The white dots should be in an irregular pattern and should be sprayed only on the top of the head in the dark area. Mike uses Life Tone off-white paint and will later make the halos green by misting them with the same green that will go on the back.

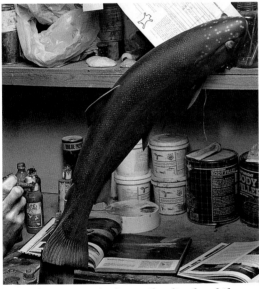

Green is applied to the tops of the fins, with the card used to mask the body of the fish.

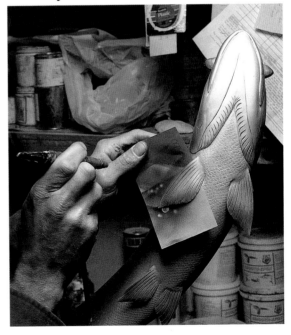

Blue is sprayed along the back of the steelhead and is misted over the spots on the head. Mike uses a medium blue auto body paint. Then, Life Tone transparent blue-green goes over most of the areas where the blue was applied, leaving the back of the fish with a dark, irregular blue-green quality that seems to change in color as the viewing angle changes.

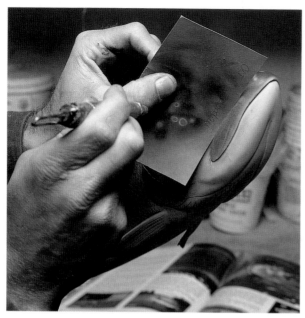

The lower jaw is darkened slightly by a misting of dark green.

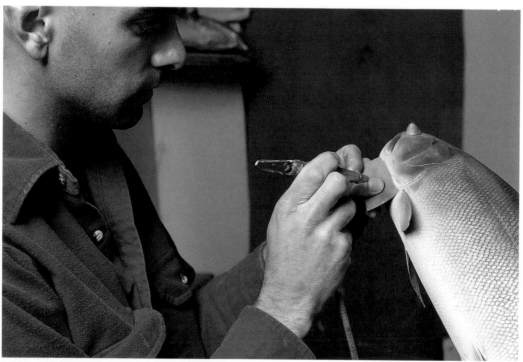

Mike uses black paint to add definition to detail along the head. He masks the surrounding area with a cardboard shield and paints the carved slots along the gill covers.

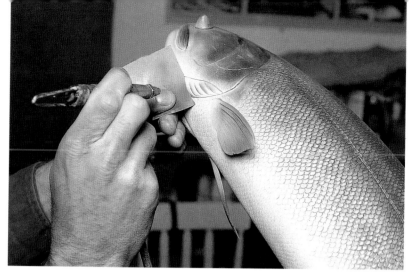

Mike wants just a small amount of paint to get into the crevices to help create shadows. Often he will paint the card itself and allow the overspray to fall into the crevices.

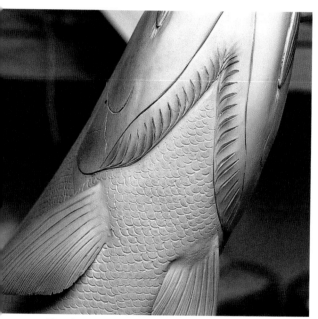

Darkening the carved detail makes it more prominent and gives it definition, such as these slits along the throat.

The ridge along the jawline is emphasized by bouncing paint off the cardboard and into the groove.

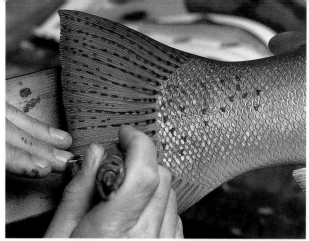

Straight black is used to add the spots. On the steelhead, all the spots are above the lateral line except those along the tail and behind the gill covers. The spots are primarily in the grooves between the scales and are usually in a Y shape. Spots on the tail are in the form of horizontal lines, and the ones on the head, with the halos, are round.

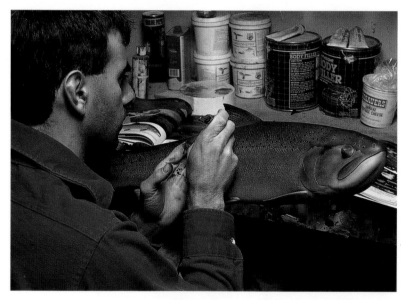

The dorsal fin and the tail fin are the only fins to have spots.

A few spots are added just behind the gill covers.

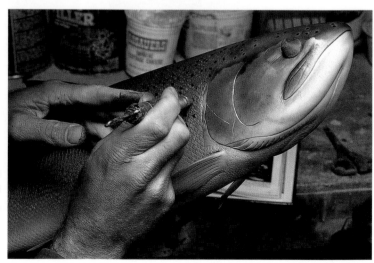

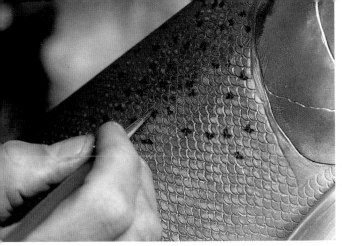

With the spots completed, Mike will again scale-tip the steelhead above the lateral line, this time using a small brush and iridescent blue.

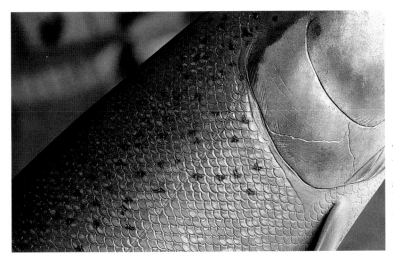

The effect is subtle, but the iridescence gives the steelhead lifelike sheen and depth, enhancing the silver scale-tipping done earlier.

The iridescence is dabbed onto the trailing edge of each scale. Mike uses a jar top as a receptacle, applying just a small amount of the material to each scale. Iridescent colors are available at taxidermy shops and art supply dealers.

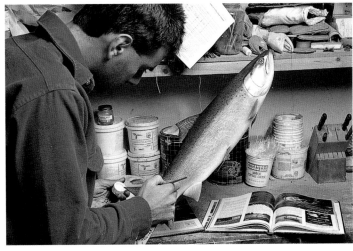

The same procedure is done on the sides of the steelhead where the pink stripe is located. Mike uses Polytranspar iridescent red here. Scale-tipping is time-consuming and the effect is subtle, but it adds to the realistic appearance of the fish. The effect will be more pronounced when the fish is sprayed with a gloss finish when the painting is done.

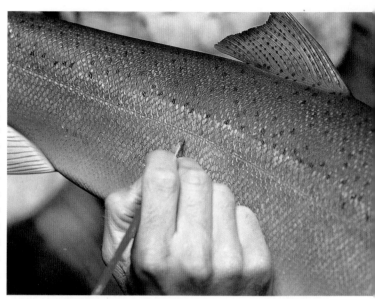

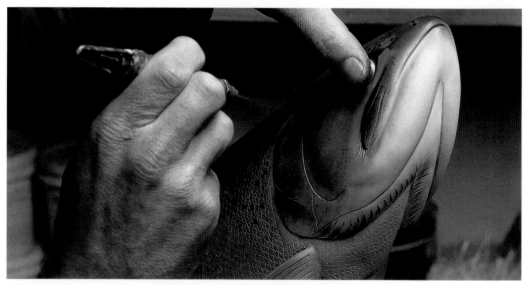

Mike wants to add some very fine white edges to the lines on the gill covers. He has discovered that the best way to do this is to first spray the area with lacquer, and then brush on white acrylic. The acrylic will not immediately adhere to the lacquer and will rub off, leaving a fine white line in the groove. Here he sprays lacquer onto the area to be painted. The clay has been removed from the eyes, and Mike shields it with his thumb.

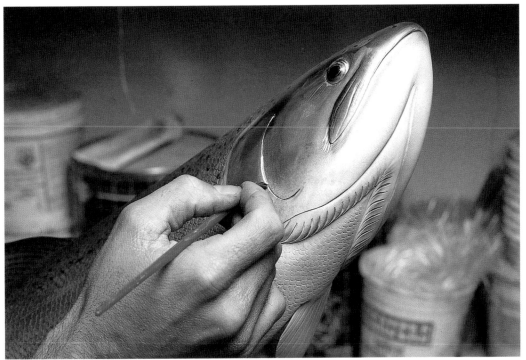

White acrylic paint is then brushed over the groove.

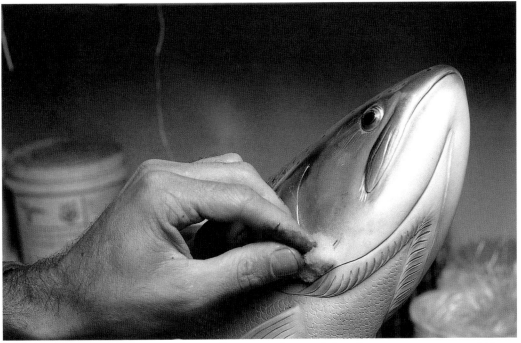

A small sponge is used to wipe away excess paint,
leaving a fine edge in the groove.

Painting is complete, and Mike finishes the steelhead with several applications of a glossy two-part urethane. He sprays the fish outdoors and wears a respirator to avoid breathing the urethane fumes. He usually applies three thin coats of urethane, allowing each to dry thoroughly.

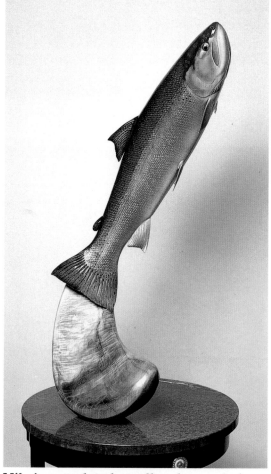

Mike's completed steelhead mounted on a wood and marble base.

6
of Our Artists

Gallery: A Look at the Work

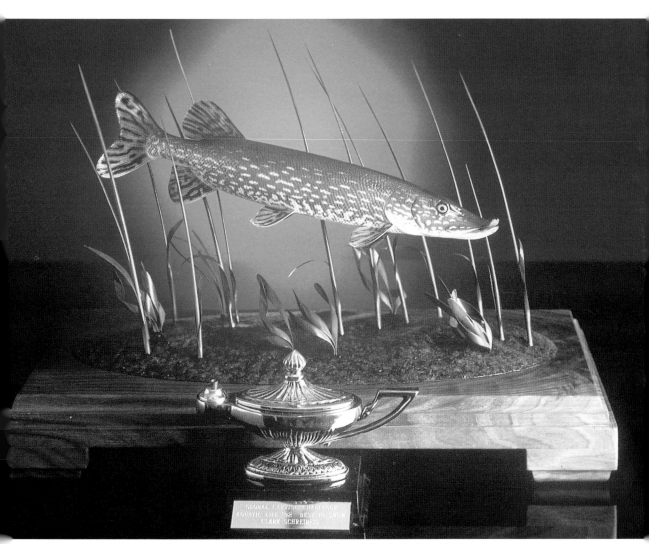

"Northern Pike" by Clark Schreibeis

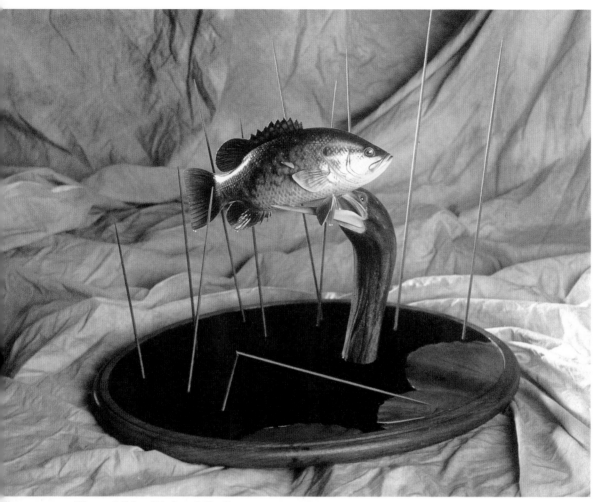

"Lunch" by Richard Roth

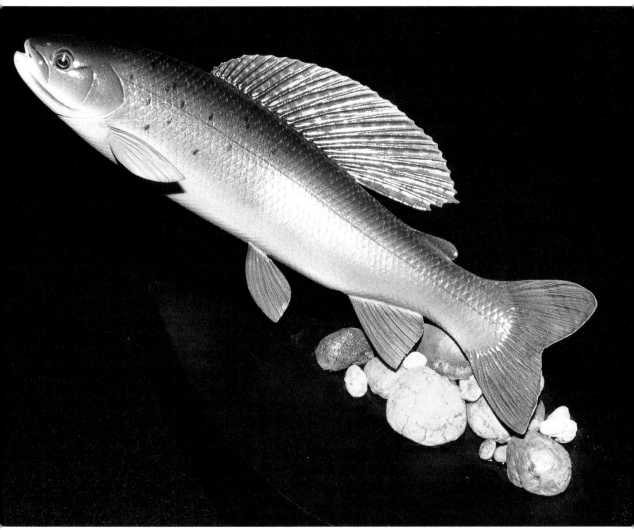

"Arctic Grayling" by Richard Roth

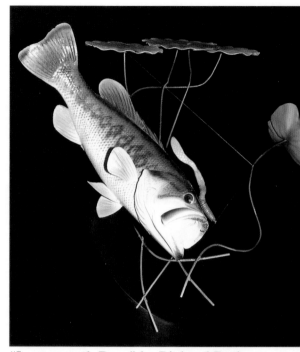

"Largemouth Bass" by Richard Roth

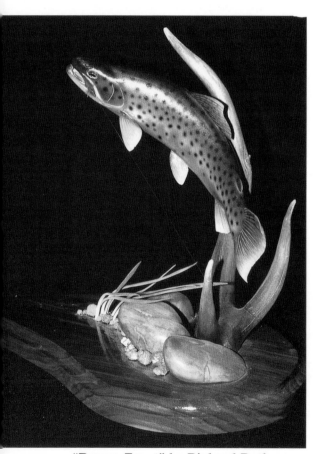

"Brown Trout" by Richard Roth

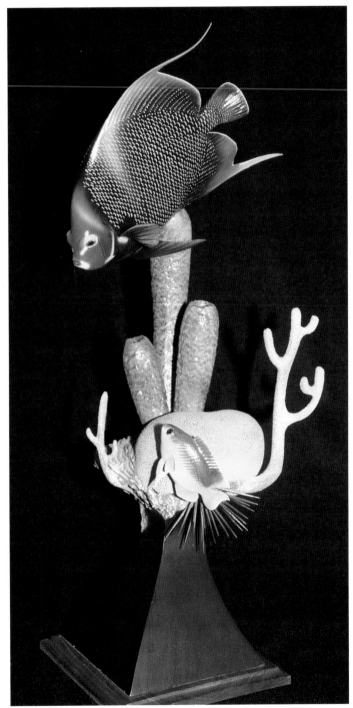

"French Angel" by Richard Roth

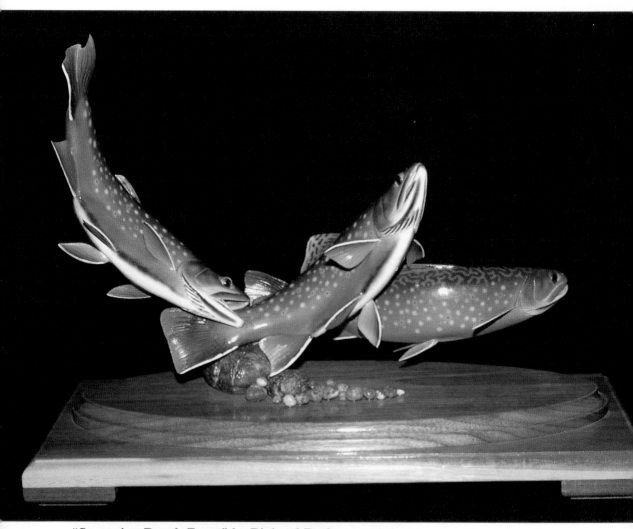

"Spawning Brook Trout" by Richard Roth

About the Author

Curtis Badger has written widely about fish and wildfowl art, wildfowl hunting, and conservation issues in general. His articles have appeared in many national and regional magazines, and he has served as editor of *Wildfowl Art Journal*, which is published by the Ward Foundation. He is the co-author of *Painting Waterfowl with J. D. Sprankle*, *Making Decoys the Century-Old Way*, and *Barrier Islands* and the author of *Salt Tide*. He lives in Onancock, Virginia.

The Bird Carving Basics Series
by Curtis J. Badger

This series offers world-class carving tips at a reasonable price. Each volume presents a variety of techniques from carvers like Jim Sprankle, Leo Osborne, Martin Gates, and Floyd Scholz. Illustrated with exceptional step-by-step photos.

The eleven-volume series:

Eyes

Feet

Habitat

Tools

Heads

Bills and Beaks

Texturing

Painting

Special Painting Techniques

Songbird Painting

How to Compete

For complete ordering information, write:
Stackpole Books
5067 Ritter Road
Mechanicsburg, PA 17055
or call 1-800-732-3669